Ordinary Me

From Survival to Success

Taneshia Marshall

Library of Congress Cataloging-in-Publication Data can be obtained from the publisher upon request.

ISBN 0-9766368-0-8

Manufactured in the United States of America

Acknowledgements

To the creator, I say thank You for keeping me sound in mind and strong in spirit every day of my existence. All that I am is the result of the love and courage You provide me.

It is amazing once something is put into the universe how much attention and interest it tends to generate. I've received so much support, inspiration and encouragement these past years from people I've known for years as well as people new to my life. Thank you for continually asking, "Is the book done yet?" Your eagerness to read it fueled my motivation to finish it.

Mae and Earnest Lupoe (Grandma and Granddad), thank you for helping me feel love since my first days on this earth. Your colorful and dramatic story telling abilities kept me laughing even when the world wasn't kind. Keithan (affectionately referred to as Brotha/Uncle), you are more of a big brother than an uncle. In the beginning our relationship was hate/like a little but those memories disappear more and more each day as our bond grows tighter. I could not imagine life without you. Gina Wheeler (Auntie), thank you for encouraging me by displaying the inspiring mixture of business savvy, refinement, beauty, and class. I extend my eternal gratitude to you for de-stressing me financially and allowing me to have the funds to keep my dreams thriving.

Bennie, Regina, and Nikki (my extended family), thank you for loving me and wanting me to be a part of your lives. You

are in my heart forever and for always. Dion Henderson (lil brother), since you have been in this world you have shown me unconditional love, enthusiasm and support. I would travel to the ends of the earth if you needed me to. I expect nothing short of greatness from you!

Special thanks to Shellie Saunders of Write Impressions, whose creativity and editorial expertise brought this book to a level higher than I imagined. Thank you for pushing me even when I felt like I was steps over the edge. Mikael Thornton of Mikael Thornton Graphic Design, you are an illustrator extraordinaire. Thank you for getting me out of a pinch and translating my ramblings into art.

David M. (Father), It is a shame we never got to really know each other before you departed this earth. I know we would have had more in common than just the freckles on our noses. Synethia (Mother), thank you for giving me life and for loving me the best way you knew how. I've learned so much from you. I see you in my actions more often than I admit. I love you.

To those family and friends I didn't mention by name, thank you for encouraging this journey called my life. Thank you for giving me space to focus and humor when I needed it. And to you the reader, I am truly grateful for your support. I hope this book proves to be inspirational, entertaining and educational. After you've finished reading Ordinary Me: from Survival to Success, do visit me online at www.tmarshal.com. I anxiously await your feedback!

Survival

A Cry for Help

"All right, class. I need you to make a single line at the door so we can exit the building," my fourth grade teacher, Mrs. Allen said. "There will be no pushing in my line. We will exit the building in an orderly fashion. When we get to the playground, you must stay together. Do not wander off. I do not want to search for any of you! Don't worry. This is just light rain, and we'll be back in the building soon," she said as we exited the school for the fire drill.

"I'm glad I brought my umbrella out here. Come stand under it Jackie," I said to my best friend.

Another classmate tried to seek shelter under the umbrella, too. "No! You can't get under it, Charles! It's not big enough!"

"Come on, Taneshia," he insisted.

"No! I told you there's not enough room."

"Ta-Taneshia isn't that your mother's car?" Jackie asked.

"I can't tell. There are too many people in the way."

"I think that's your mother. She's walking over here."

"She must have recognized the umbrella," I said.

My mother was slim and had hips that bowed out. She threw her hips when she walked, exaggerating her stride. All of the clothes in her wardrobe showed her shape.

Her visits to my school were few, but when she appeared, some of the boys would say, "Your momma is fine!" She liked

to attract attention and she got a lot of it. There was always a man in my mother's life.

When she reached me, I spoke. "Hi, Momma."

"Did you find your keys?" she asked.

"Umm, no I haven't found them yet."

"You remember what I told you would happen if you didn't find your keys?"

"Yes," I said, frightened.

"I've got to go to work, so take this key. I'll see you on my lunch break." She walked away.

My mother's lunch break would be the time of my execution.

Jackie attempted to ease my comfort. "Taneshia, don't cry. Everything will be okay. You can come home with me after school. Everything will be okay. Don't cry."

Concerned for my safety, Jackie persuaded me to go to her house after school, despite the directives of my mother. I knew that disobeying my mother would instigate a volatile situation, but I was terrified of waiting for her to come home.

"Maybe you can spend the night with us tonight," Jackie told me when we got to her house.

"No, I will go with my grandma and granddad."

I called my grandparents from Jackie's house. They were not home, but I left Jackie's telephone number with my uncle. I told him to have my grandparents pick me up. I tried to communicate the urgency as best I could to my uncle and prayed that my grandparents would find me before my mother did.

"Well, maybe you can stay for dinner," Jackie said.

We were playing with her dolls in her room when we heard her mother call my name.

"Taneshia! Taneshia! Come out here, baby!"

"Yes, Mrs. Thomas?"

Jackie's mom met me in the hallway. "Your mother is here,

baby," she whispered.

"Please don't make me go with her, Mrs. Thomas! Please!" Jackie's pleas followed. "Please! Momma, don't make Taneshia go with her!"

"Baby, I can't keep you from your mother. That's your mother, and I can't stop her from taking you."

"Please, Mrs. Thomas. She will hurt me."

"Momma, please don't make her go!" Jackie begged.

"I'm sorry, baby. That's your mother."

I went back into the room with Jackie to get my backpack. I knew my grandparents would call, so I asked Jackie to tell them that I'd gone home with my mother.

When we were outside of Jackie's house, my mother released her fury. "Get your ass in this car! I'm so mad at you! You had me looking all over for you. I told you to take your ass straight home from school! Today you will learn to do what I tell you to!"

"I'm sorry, Momma. I'm sorry."

"No, it's too late for that. Your ass will be sorry." My mother was speaking through her teeth as she often did when she was angry.

I sat alongside her, praying to God, begging that He would let my grandparents be at the apartment waiting on us. I sat in fear of what was about to happen, clutched my backpack to my chest, and hoped that it would provide me with some protection—at least while we were in the car. I wished the car ride would last longer so that my mother would only have time to drop me off and go back to work. I had no such luck. My mother must have broken all the speed limits in a rush to get home.

We pulled into the parking lot of our apartment building and Sonya, our neighbor, was outside. Sonya was a young mother with twin sons. She was pretty and slender, like my mother.

When she and my mother went out, Sonya's boys would keep me company. I liked Sonya, and in some ways, she reminded me of my mother.

On that day, she spoke to my mother, who did not speak back. My mother only threw her arm in the air as if she were in a hurry to get into the building.

As I walked slowly toward the building, I turned to Sonya with tears in my eyes. I wanted to scream, "Help me!" but my lips stayed shut. I looked at Sonya, wishing she could read my mind and hoping that she would stall my mother. I knew that time was a factor and if my mother wasted too much time, she would have to return to work. Sonya had to have sensed that I was in trouble. She looked at me with concern in her eyes, but remained silent.

We walked inside the eight-unit building. We lived on the first floor, which was easy access for both us and burglars. My mother tried to ensure our safety by getting a barred security door and putting iron bars on most of the windows. I stood frozen in terror as she unlocked the iron-barred door to the apartment. I knew what was waiting for me inside.

Mentally, I wanted to break down. I walked behind my mother still grasping my backpack close to my chest, as if it were my shield. My mother directed me to prepare for my punishment, but she did not yell. The walls in the building were as thin as paper. Sometimes I could hear the noisy conversations of our neighbors.

My mother never wanted the neighbors to hear her yell, nor did she want them to hear me scream when she beat me. I was always forced to shut my lips while she struck me. If I didn't, the beatings would last longer. Once, she went to the extreme of gagging me with a cotton scarf to keep me from screaming. With my lips clenched, the screams sounded more like muffled groans,

but they still made great vibrations in my throat and chest. But that day, I wanted to let out the screams, for all to hear. Maybe then someone would have an idea of what was happening to me.

My mother told me to go into my bedroom and take off my clothes while she looked for the extension cord. I stood in my room, trembling. My heart pounded through my chest. Tears fell down my cheeks. I had been praying for some relief the entire time, but at that point, I stopped praying. I felt as if God had been too busy to hear me.

I hesitated to take off my clothes. I stood in front of my doorway and was moving the elastic waist shorts down my legs when my mother came into my room. She started rushing me. Immediately, I stepped out of the shorts, leaving on my underwear and tee shirt. I assumed position with my back to my mother and my arms extended in front of me. She made me hold out my arms so they would not be struck and scarred like my thighs and buttocks.

The first strike of the extension cord was quick. The cord always made a zip sound when swung, as if it were slicing the wind. The second blow was more piercing. I jumped as if I were stepping on hot coals. My mother mumbled words through her teeth as the beating intensified. By the third blow, I turned around. I wanted her to see the tears in my eyes and on my face. I wanted her to see and feel my pain. She told me to turn back around and I did.

As the next blow was delivered, I arched my back and stuck my chest out so that the cord would miss my body. My mother commanded me to keep still. I felt two more lashes—one across my buttocks and the other on my right thigh. I bit my bottom lip, trying to hold in the screams. After the next three lashes, something came over me. I ran.

I slid behind a chair and under the matching wooden desk for protection. I grabbed onto the legs of the chair, hoping to keep it in front of me.

My mother screamed, "Come out from under that desk!"

I tightened my grip on the legs of the chair. My breathing was hard and fast. She grabbed the chair, yanking it from my hands and pulling it out of my reach. I stayed underneath the desk with the cool wall against the hot, throbbing skin of my back. My mother grabbed the edges of the desk with the cord still in her right hand. She pulled the desk away from me.

"I will *kill* you!" she yelled. She no longer cared if the neighbors heard.

I crawled to the edge of my bed, trying to find any space in my room that would make it difficult for my mother to reach me. Clutching a corner of my bedspread, I leaped onto my bed and wrapped myself in the spread like it was my cocoon.

My mother resumed the lashing. The spread was thin enough for me to feel every blow. I screamed and begged her to stop. She let the cord land on my head and my back. I scooted to the side of my bed nearest the wall and attempted to cover myself with the bedspread, positioning my body in a way that would avoid the full impact of the cord. My mother reached for the cover and tried to rip it off of me. I struggled with her, holding the cover with all the strength I had in my bleeding and weary body.

I felt the cover move away from my body and then off of my face. As the spread slid away, I looked up at my mother. She was enraged. Her eyes were red and her face was shining from the sweat. She clenched her teeth tightly, groaned like a wild animal and let out a roaring sound.

She jumped on top of my bed, and I was terrified. I had never seen her with so much anger. It always amazed me that someone so beautiful could have such an angry temperament.

I thought she was going to kill me.

I was on my side, watching her raise one of her legs, then lower it. Her thick, rubber soled Hush Puppies came toward me and I covered my face with my hands. The shoe crashed against my hands. Still, my cries were muffled. My mother continued to roar while stomping on my face and arms. My hands began to weaken, exposing my face, slightly. Finally, when the stomping ended, I dropped my hands. My mother jumped from my bed to the floor.

My mouth fell open. I could not catch my breath. There was still anger in my mother's eyes and terror in mine. She picked up the window fan that sat next to my bed and raised it over her head. I put my hands in the air, trying to block my body. I begged her not to throw the fan. She hesitated for a moment, contemplating. Then she threw the fan to the floor.

The beating was finally over. I lay on my bed in the fetal position, crying. My mind and body seemed to go into shock. My mother's grunting ended, too. She was able to form complete words and sentences. She told me to clean up my room, which looked as if a hurricane had blown through, turning over the furniture. She also instructed me to clean my wounds and prepare myself for her return later that night. She told me she would whip me all over again.

My mother left and went back to work. She had taken all of the keys and locked me in the house. We had a deadbolt lock on the door that could only be opened with a key. Beyond the front door was the iron-barred security door that also required a key.

I lay in bed, quivering. My skin stung from all the lashes. My head was pounding from the stomping. At that moment, I wished I were dead. That wish of death was not the first, but it was the greatest. I got out of my bed and hobbled slowly to the bathroom where I started to clean my wounds, as I had been

told. The water that filled the sink turned from clear to pink as I rinsed the blood from the washcloth. I stood at the sink, tasting the salty tears that streamed down my face. I continued to pat the wounds on my thighs and stomach. The cool water soothed the stinging.

I could not bear the thought of what would happen when my mother came home from work later that evening. I went to the kitchen and pulled the biggest and sharpest knife from the utensil drawer. I returned to the bathroom and stood in front of the mirror. Grasping the thick plastic handle with both hands, I positioned the knife with the sharp edge to my stomach. I pressed the knife to my stomach, but only hard enough to make an indentation. I pressed again making a deeper indentation, but dropped the knife. I was too much of a coward to take my own life.

Distracted by knocking that came from the living room window, I ran into the living room and peeked through the horizontal blinds. It was my grandparents. My grandfather was calling me through the window. "Grandma, grandma!" That was his nickname for me.

My grandmother was standing beside him at the window, looking in curiously at my tear-stained cheeks and red eyes. I tried, but could not open the living room window. I went to the narrow window in the kitchen and turned the handle. It was the only window in the apartment that did not have bars. I had only opened the window slightly when my grandfather started asking questions.

"What did she do to you?" His voice was raspy but loud.

My grandfather was a small-framed man, and soon I would be taller than he. My grandmother stood at his side. She was larger than him and had auburn hair in big curls that were swept to the back. I stood at the kitchen window feeling the warm sun

as it shined behind the heads of my grandparents. I stood behind the window as tears continued to run down my face.

My grandfather asked, "Is that blood on your shirt, grandma?"

"Yes," I answered. I turned sideways and lifted my shorts so that they could see my thighs. My wounds bled through the yellow, terrycloth shorts.

My grandmother yelled out, "Look what she did to her, Henry!"

I faced forward again and I saw my grandmother's eyes swell with tears. She stood with her hand over her mouth.

My grandfather directed me to come out of the apartment, but I was locked in. He ripped the screen off of the kitchen window after my grandmother commanded him to. He reached for me and I ducked out of the narrow window, holding my bloody left arm to my chest. My grandfather held me in his arms. He threw the screen in the kitchen and slammed the kitchen window shut. He asked if I felt okay to walk. I told him I did, so my grandmother took my hand and led me to the car.

I eased into the back seat of their big, silver Grand Marquis and was careful not to let my wounds touch the seat. My grandmother sat in the passenger's seat and my grandfather got in the driver's seat. He assured me that everything would be all right and I knew he was telling the truth. I always felt protected with my grandparents.

As we drove away, I gazed at the apartment. My mind was blank and my body was throbbing. I saw tears drop from my grandmother's chin, as I looked at her in the rear view mirror. She was silent, but my grandfather cursed my mother as he drove. I tried not to move because it hurt too much.

Somebody Listened

My grandfather pulled up to the emergency entrance of the hospital. My grandmother got out of the car and told me to wait. The automatic door opened and she returned with an orderly. A tall, lean man dressed in mint green scrubs pushed a wheel chair to the car. My grandmother opened my door and the man pushed the passenger seat up. He reached for my hand and helped me out of the car. The man asked me if I was in any pain.

"Yes," I replied.

He sat me in the chair and rolled me inside the hospital, rushing me past the crowded waiting room and into a small area that was shielded by a curtain.

That was the first time I had been in a hospital. For a moment, I was lost in the atmosphere of the hospital's smell and activity, as staff members raced through the white hallways.

My grandmother was by my side. I had stopped crying. The only tears I saw were those in her eyes. The orderly placed me on the hospital bed. I was lying on the bed, staring out of the window and into the sky. I often daydreamed that I was sitting on the clouds.

My grandmother had said very few words and held my hand as we waited. Sharp pains shot through my body. I listened to the shuffling behind the curtain, then I heard my grandfather calling for my grandmother.

She answered, "In here, Henry!"

My grandfather reached through to pull back the curtain. He asked my grandmother if the doctor had been in to see me. He had not, so my grandfather wasted no time getting to the nurse's station. His voice carried down the hall as he told the nurse that someone needed to see his granddaughter. The nurse said that someone would be with me soon.

My grandmother sat in the chair next to my bed.

Granddad returned to the room and stood over me while facing my grandmother. "How could she beat this child like this?" he asked.

My grandmother sat silently with tears in her eyes. She held her purse in her lap.

Blood tricked down my stomach. My arms and legs were still throbbing. I wondered what would happen next.

A pink, flesh-colored hand reached between the curtains that separated me from the aisle. A tall woman appeared in a white nurse's uniform. She walked toward me, smiling.

"How are you today?" she asked.

"O-okay," I stuttered. She asked me where it hurt. Before I could reply, my grandfather interrupted, telling the nurse that my mother had beaten me. The nurse's face turned red and her eyes widened with concern. She asked me if I could move my arms and legs.

"Yes," I told her.

The nurse pulled out a white, paper gown and turned to my grandmother asking her to help me change into the gown.

My grandfather walked away, saying he was going to look for the doctor. Granddad had a way of nagging people into action. Waiting was not in his character, and he didn't think the hospital was reacting to my needs quickly enough.

I could tell that my grandmother was disturbed by the entire

ordeal. She rose from her chair, leaving her purse. She reached for the paper gown and placed it on the chair. My grandmother pulled off my shoes then told me to lift myself from the bed and stand on the floor. She wrapped her arms around me and proceeded to pull down my blood-stained shorts. That was the first time she saw my wounds clearly. She paused, looking at the bloody sores on my right thigh.

"My goodness! I can't understand how your mother could do something like this to you," my grandmother said.

She finally got the strength to ask why my mother beat me. I told her it was because I lost my house keys even though I knew it was because I lost my keys and did not go home after school.

My grandmother grabbed the bottom of my shirt. I raised my arms so she could remove the shirt. The throbbing in my arms intensified. She put the paper gown over my head and turned me around to tie it.

I heard my grandfather's voice and another man's voice on the other side of the curtain. The other voice asked if it was okay to pull back the curtain. My grandmother granted permission. My grandfather appeared with a nurse and a doctor. The doctor was a young man with a pale complexion and dirty blonde hair. He put his hand on my forehead and rubbed it gently. The doctor assured me that he'd help the hurt go away.

He asked me who had hurt me and I told him it was my mother. He wanted to know exactly what she had done, so I told him and left out none of the gory details. Tears welled in the eyes of the doctor, the nurse and my grandfather as I recounted the story. My grandmother's tears continued to roll down her cheeks.

As the hours passed, I watched the sun fade into the clouds. By that time, my grandparents had left the hospital room, but

remained nearby.

The doctor checked me for broken bones and sore spots before stitching the open wounds on my stomach. The nurse made idle conversation with me to take my attention off of the stitches. When the doctor finished, the nurse asked about my school and friends while she dressed the wounds on my arm, lower back, thigh and buttocks. After she finished, my grandparents returned to my room just as the doctor was on his way out.

My grandfather asked, "How you feel, Grandma?"

"Okay," I responded quietly. The pain had not gone away.

The doctor returned and asked for my grandparents. They all stepped outside. A few moments later, the doctor returned with two police officers and asked me if I felt up to answering some questions for the officers. I nodded my head and started to sit up. The nurse put her hand on my shoulder and reclined the bed. The officers asked the questions that the doctor had asked me earlier. One of the officers had the same expression on his face as the nurse did when I told her what happened. By then I had told the story so much that I was able to get through it without emotion.

Things Would
Never Be the Same

My summer vacation started early. I did not return to school or get the chance to say goodbye to any of my friends. I missed them and my teacher, Mrs. Ganyon.

I moved in with my grandparents. My cousin and uncle also lived with my grandparents and were raised like brothers. My cousin was the eldest grandchild, and his mother was very young when she had him, so my grandparents took custody of him. I often wished they had custody of me, too.

My uncle was five years older than me and was the only child my grandparents had together. He was the baby of my grandmother's seven children, but when I was around I became the baby of the house.

We behaved like siblings. Like a big brother, my uncle would tease me about being overweight.

He would sing a song to me over and over:
She's new.
She's Taneshia.
She's a big woman, big woman.
Hippopotamus.
She's eating up this world.
Stealing cookies from boys and girls.

He used to taunt me by making his teeth chatter while shaking his finger. He would move closer and closer until I'd yell, "Stop it! Stop it!"

All of my friends in the neighborhood wanted to know why I wore bandages. Once I had the bandages removed that summer, loop-shaped scars were visible on my right arm and right leg. I was either teased or pitied. One of my cousins did most of the teasing. I had cousins who lived on the same block with my grandparents. They were my father's nieces and nephew, and they lived in a house with their mothers and grandparents.

I never felt close to that set of grandparents. My parents started going out while they were in high school, and my mother became pregnant with me when she was 14. My father wasn't too much older. He had never taken any responsibility for me, and his mother never acknowledged me as one of her grandchildren. I don't know what my paternal grandfather thought of me. He always smiled and acted as though he liked me, but I was never treated like the other grandchildren.

Intermittently, my father lived in that house with his parents, sisters, nieces and nephews. He was upset at my mother for abusing me but his anger did not have much merit. My father was in no position to take care of me, and I don't think he wanted to. I didn't even know if he had a job, and I never spent any weekends or holidays with him.

People in the neighborhood knew my father abused alcohol and drugs. He gave me small presents like pictures that he drew, but my mother was the only person I looked to for birthday and Christmas gifts. I depended on her for new school clothes and shoes. Despite the abuse, my mother was my world, and I always wanted to make her proud of me.

After a few weeks of living with my grandparents, my mother started calling and visiting. That July I turned 10, and my mother gave me a birthday party at my grandparents' house. She gave me a brand new 10-speed bicycle. At that moment, it felt as though life could not get any better. I was staying at my favorite house near friends and family. The best part was knowing that my grandparents would not let my mother hurt me.

When my grandparents were gone, I felt vulnerable because they were my protectors. When they traveled, like they did that summer, I stayed with relatives. My mother always found out where I was. Her mode of operation was to be in control, always. Her lack of control in those situations manifested into anger.

When my mother was angry, she was volatile—like a stick of dynamite. I did not feel safe with anyone other than my grandparents and was always relieved when they returned. Most of my relatives refused to watch over me because of my mother's rages.

She would go to my relatives' houses, scream my name from outside, and demand that I go with her. She'd yell, "That's my child! My child!"

I remember trying to find a corner of a room that was far from her screams. I would squat down, putting my hands up to my ears and burying my head between my knees until the screaming stopped.

On one trip, my grandparents went out of town for a week. I was sent to stay with my aunt and her two kids. My aunt was my grandmother's younger sister. Her daughter who was one year older than me and her son was my age. My mother found out where I was staying and decided that was her chance to get me back. She came over, and my aunt met her at the door, keeping the screen door locked.

I was upstairs looking down at my mother through a big

picture window. My mother asked if she could see me. My aunt told her no and said she should not have been there. My grandparents had instructed my aunt not to let me have any physical contact with my mother.

As my aunt walked away, my mother started to beat on the screen door. She yelled, "Taneshia come down here!" repeatedly.

I ran away from the window. I was terrified that my mother was going to take me. A neighbor called to ask my aunt if she knew that a woman was on the porch screaming. My aunt told the neighbor not to call the police and that the woman would go away soon.

My mother continued to yell for me to come down. I had seen that anger before and I knew what it led to. Afraid, I turned to my aunt and said, "I gotta go. My mother is calling me."

My aunt bent to look into my eyes and said in a stern voice, "You are not going anywhere. Don't be afraid. I won't let her take you."

I stood near the window, far enough out of view that my mother could not see me. Tears began to roll down my cheeks as I listened to her. I was afraid on that day and the ones that followed until my grandparents returned.

I witnessed many changes that summer. My mother and I were not together and her rages scared me. When my grandparents were home, I realized their marriage was falling apart. Things weren't like they used to be.

When I was a young girl, my grandparents gave parties at their house. Many of their friends and relatives would come over to laugh, eat, drink and dance. My grandparents did not smile or laugh together anymore. My grandfather seldom stayed in the house. They argued and sometimes it ended in physical

fighting. My cousin and uncle always tried to stop the fighting.

Several court hearings were held on my behalf that season. I never got to see the judge or the actual courtroom. I spent most of the time talking to strangers in the cafeteria. They were either social workers or attorneys who always asked me about how my mother treated me. When they asked if I wanted to return to my mother, I'd always say yes. I loved my mother and I missed my room with my clothes and toys.

I never saw my mother at any of the court hearings. The court hearings were always brief, but waiting for the case to be called lasted for hours. There were many children, young and old, in the waiting room. Some of them were with their families and others were with police officers.

I always slid down in the hard brown plastic chairs. They were shaped like question marks that were flipped bottom-side up. I would sit there, gazing out of the big picture windows, watching the cars drive by. My grandparents would sit beside me and take turns talking to the social worker or the attorney. My grandmother and grandfather always had saddened expressions on their faces. With all of the tension between them, I did not know if the sadness was because of my problems or theirs. No one ever said anything to me about what was happening. I just went with the flow.

The Home Away from Home

One day my mother came to my grandparents' house with a social worker. The social worker was a middle-aged woman in her early forties. She seemed nice and she always smiled. She would ask me about my friends and school. The social worker also asked if I loved my mother and wanted to live with her again. I answered yes to both questions. I did not know if I was answering out of truth or fear.

My mother and the social worker visited about once a week. One of my grandparents was always present in the house but was never in the same room with us. It seemed as though my mother was a different person. She smiled and laughed more and she seemed more loving toward me. I didn't see the other side—the mean and violent side that made me afraid.

The social worker called me one day while I was at home with my uncle. My grandfather had not been there for days and my grandmother was at work. The social worker told me to get all of my clothes together because she was going to take me somewhere for a little while. I felt as though I could trust her, so I did as she said. When I told my uncle that I was leaving, he got upset. He asked if Momma knew I was leaving. Momma was what we both called my grandmother. I told him that the social worker assured me that my grandmother knew I was leaving, but I thought it was kind of strange that my grandmother did not

mention it before she left for work. If she knew that I was leaving, I wondered why she didn't help me get my clothes together the night before.

The social worker arrived about two hours after the phone call. She seemed hurried. My uncle and I had set black garbage bags full of my clothes at the door. The social worker rapidly took the bags outside and placed them in the trunk of her car. I gathered the last of my things. As I turned to my uncle, I noticed he had tears in his eyes. With tears in my eyes as well, I said, "Goodbye."

I got into the social worker's car and we drove for a while before pulling in front of a huge brick building. It looked like a mansion. The social worker grabbed my bags from her trunk. I was silent as we headed up the walkway. She told me that I was going to like it there and would have lots of children to play with. As we walked farther I saw a sign on the lawn that read Denby Home for Children. At that moment I realized that my time away from my family was not going to be short.

When we walked into the building, the director of the home greeted us. She was tall and slender with short blonde hair and glasses. She looked like a man. She leaned toward me, smiling, and asked me my name. I could not hold the tears back any longer.

I turned to the social worker and screamed, "I want to go back home! I don't want to stay here!" She told me to stop acting out. Her caramel colored face turned red.

"Take me back home! Pleeease take me back home!" I begged the social worker.

Two men came to the doorway where we stood. Both of them took my things. The director grabbed my hand and pulled me toward her. She told me that everything was going to be okay and started to pull me toward a brightly lit, long hallway.

I was crying uncontrollably as I watched the social worker walk out of the door.

The director took me down the hallway and into an office. She tried to comfort me by rubbing my shoulders and saying that everything was going to be all right. Another woman entered the office. She was a small woman, just a little taller than me. She was very pretty with dark brown skin and long black hair. I thought she looked like one of my brown-skinned dolls, and I felt more comfortable with her than the director. She asked me if I wanted to go outside and meet some of the kids who lived there. She took my hand and we headed back down the long hallway. The building looked as big as my school and had white walls and floors.

It seemed as though we walked for five minutes before we got to the door that led to the backyard. The yard looked like my elementary school playground. There were swings, slides, monkey bars, seesaws, picnic tables and sandboxes that covered the entire yard. There must have been at least 100 children playing there. They were all different ages and races. There were even little babies crawling around. Though the home reminded me of being at my old school, I knew the major difference was that I would have to sleep there.

I was assigned to the girls' unit. The girls ranged in age from nine to 16. I no longer had my own bedroom and shared a room with five other girls. We each had twin beds with two drawers in the base of the bed. We shared rolling racks that served as our closets. Some girls did not have clothes of their own so they had to find outfits from the clothes room, where donated clothes were kept. I had to wear outfits from the clothes room until my personal clothes were marked. Marking was the process of writing the initials of each resident in his or her clothing and shoes. Even the underwear had to be marked. That kept

the other girls from stealing clothes.

Visiting days were once a week and my mother started visiting me about twice a month. She always had something for me, whether it was a pair of shoes, clothes or toys. Once, she brought Pennie, one of the girls, a pair of shoes as payment. Pennie's job was to protect me from the other girls in our unit. Pennie was intimidating to most of the girls. She was like a giant at 14. In my 10-year-old mind, she looked as if she were six feet tall and weighed 200 pounds. She took her job very seriously and made sure that no one bothered me at the home.

The school I was attending was right next door to the home. I couldn't bear to tell my new school friends that I lived in the home. At the end of the school day, I was always either the first or the last one out of school because I didn't want anyone to see me entering the gate to the home. It was hard enough to make up stories about the scars on my arms and legs.

I would hear the school kids taunt some of the other children from the home saying "Your mommy and daddy didn't want you," or "You must be crazy 'cause you live in the place with the crazy kids."

It was difficult trying to maintain a normal identity, but I did for as long as I could. When questions became too personal, I would change the subject.

My mother was seeing a lawyer and going to court in attempts to regain custody of me. I wanted to go back home with her. Having other kids around all the time was better than being home alone, but I missed my old friends, my old school and my own room. I also missed being with my mother. Life with her was okay when I didn't make her angry.

Two seasons passed. Spring was just arriving and my mother

had won her battle. I was saying goodbye to my friends and the staff at the home. I would miss them as well as the friends I made in the new school I was attending, but I was ready to start over with my mother.

A Fresh Start

I moved back in with my mother and was able to finish my elementary education with most of the friends and classmates I left during the previous year. My mother soon upgraded from our apartment to a townhouse around the corner. At the time, it seemed to be for the best. A new house meant new experiences, far removed from the old apartment's haunting memories of past whippings.

Our new place seemed to represent a new beginning for our relationship and opportunities for new neighbors and friends. The townhouse was more spacious than the apartment. It had three levels with a basement. The walls still seemed to be as thin as paper and I often heard the voices and sounds of the neighbors in the adjoining units during the day or night.

The man who lived next door belonged to a motorcycle club. His name was JD and his appearance was fitting of a biker. He was a wide, towering man. His mustache and beard covered most of his dark face. JD's hair was like a bush that spanned from ear to ear. He often wore black jeans with a black cut-off shirt. He added a black leather jacket when it was cold. His voice was deep, powerful and low. JD often told me that if I ever needed him, to knock on the wall and he would come over. He knew I was often home alone while my mother went to work at the grocery store. My mother only seemed to be concerned with

JD when she wanted to get marijuana from him.

The street we lived on was filled with kids who would be attending my new junior high school that Fall. I had the most interaction with the three sisters who lived about seven doors down. Each sister looked different from the next. Michelle, the youngest, resembled their mother the most. Lena, the oldest, was a year older than me but at my grade level. I related most to the middle sister, Sonét. She was a year younger than me and was the smartest and most obedient of the three. She also seemed to be the one who got picked on and teased by her siblings.

I spent a lot of time at Michelle, Lena and Sonét's house. Their mother, Jo, was raising the three girls by herself. I seldom heard any of them speak of their fathers—they each had a different one. Like my father, theirs were not around. The more time I spent there, the more I became part of their family. Sometimes I helped Lena and Sonét with kitchen duty. I always jumped at the chance because I liked being around them.

If their mother started yelling and turning red, I would usually leave. I did not want to see any of them get punished— except for Michelle, sometimes. Michelle was annoying at times and mischievous. She would get her big sisters in trouble, and for that she deserved to be popped a few times. I never left when Michelle got yelled at.

Jo and the girls had a relationship that I admired. Even though Jo yelled at times, her love for the girls was evident. It showed in their interaction with each other as well as in their outward appearances.

Jo kept the girls dressed to perfection. They each had more than an adequate amount of clothing and shoes. The sisters were all different sizes but each of them was slim. Sonét was skinny and her sisters often teased her about it. She would retal-

iate on Lena by teasing her about her backside. Lena's behind stuck out like a shelf. The teasing never really bothered Lena because her shelf-like booty kept the boys around her. Lena had boyfriends before I even understood the significance of having a boyfriend.

It was clear that if a boy liked me but Lena liked him, our friendship would be in jeopardy. Sometimes she tried to resort to physical fighting, but Lena was more talk than anything. I never thought that much of any boy to damage my relationship with her and I often ignored the advances of boys I knew she was interested in.

Once, Lena picked a fight with me in front of a crowd of our schoolmates. It was over a boy named Tionne who lived near the end of the block, in an area where we did not often venture. He should have been in high school but was held back a few times. Tionne was the first boy in the neighborhood to grow facial hair. It was actually more like peach fuzz on his upper lip but in my eyes, he was almost a grown up. Tionne was tall and his physique resembled a basketball player. His complexion was like that of a peach, reddish yellow in tone. His hair was almost the same shade of red as the freckles underneath his eyes. He had what we called "good" hair—fine and curly. A Kangol hat often concealed it.

Tionne had the reputation of being a "bad boy." He hung with high school boys who fought and smoked cigarettes. I never saw him fight or smoke, but I did witness him talking back to adults, especially our school bus driver. Tionne was definitely not the type of person I associated with by choice or by permission. My only interactions with him were occasional glances from him in the school hallway or on the school bus.

The bus had invisible dividers. The front section was for the

disabled and the kids who misbehaved. The middle section was for the regular kids, who were generally the "do gooders." And then there was the back section. Tionne sat at the back of the school bus and no one dared to sit in his seat. The only kids who sat near Tionne were the boys who wanted to be like him and the girls who liked him. Lena was one of those girls.

Lena left the safety of our middle section of the bus to sit near Tionne. He talked to her every now and then but did not pay her as much attention as she wanted. One week Tionne was instructed to sit in the front section of the bus for being disrespectful to the bus driver. Lena moved back to the middle section so she could be close enough to talk to him. Meanwhile, I maintained my spot in the middle section with my friends, until the bus pest, Ronnie Jones, targeted me.

Ronnie was known for making practical jokes that were never funny to anyone. He was a little on the strange side. None of the kids really hung around Ronnie and he was kind of a loner.

Once, he was thumping me in the back of my head and I yelled out loud enough for the bus driver to pull over. The driver told me to sit in the front next to Tionne, and told Ronnie to sit in the back by himself. Ronnie did not like being isolated and decided that he would make me pay for his punishment by planning to fight me after the bus ride. Instead of the driver letting everyone off at the stop, she let Ronnie off in front of his house before dropping the rest of the kids in the neighborhood at the regular stop. By the time the bus pulled up to the stop, he had run the distance between his house and the bus stop. I could hear him yelling behind me, and soon he was close enough to point his finger in my face. I did not think he wanted to hit me but I wasn't going to take any chances. I was not afraid of him.

I dropped my backpack, turned to face him and pushed him as hard as I could. My mother heard all of the kids yelling and

she ran outside. She grabbed Ronnie by the collar and told him that if he ever put his hands on me, she would break his neck. It was enough to scare him because he ran off.

The next morning my mother waited at the bus stop with me. She talked to the driver, and I had to sit in the front of the bus, away from Ronnie. That meant that I sat next to Tionne again. Ronnie tried to get close enough to bother me, but Tionne was not having it. Since Ronnie was afraid of Tionne, he finally left me alone. Sitting next to Tionne gave me a sense of peace on the bus ride until Lena became jealous of the attention Tionne was giving me. She was going to pick up where Ronnie left off.

At the end of the day, Lena got off the bus cursing at me and pushing me from behind. I let her push me because I did not want to fight her. She was my friend, and I did not really like Tionne. He was cute, but I wasn't even thinking about boys.

Lena pushed me one more time and just like the day before, I dropped my backpack. I got in her face, determined that I would not allow her to keep pushing me around. My mother heard all the kids yelling and ran outside. This time she separated the two of us and grabbed me by the arm.

"I can't understand why you keep getting into so much shit. I am tired of it, Taneshia!"

My mother continued to yell as we went into the townhouse and walked up the stairs toward our bedrooms. She told me to take off my coat. Soon she was in my bedroom where she grabbed the tennis racket from a corner and came toward me.

I had seen the look in her eyes before. She was squinting. She started talking, but her mouth was nearly closed. I knew what was about to happen. Since I had returned home, my mother was careful not to hit me with extension cords, but she did find alternatives. Occasionally she slapped me across the face or on the mouth. Once, she choked me when a teacher called home say-

ing that I had been talking too much in class.

This time she felt the need to use more than her hands. I watched the tennis racket as it was raised in the air. I lowered my head as the racket came crashing down on my crown. The metal racket pounded my head a few more times and I fell to my knees, attempting to cover my head with my hands.

My mother began striking my back and my arms with the metal racket. She commanded me to rise. I hesitated, but after feeling three more blows across my head, I stood to my feet. I did not scream and I did not run from her. I knew that always made the beatings last longer. She was incensed and continued to swing the racket, hitting my face. I backed toward the stairs, attempting to block the blows. I slipped down three of the stairs, but grabbed the banister before falling down the rest of the stairs.

My mother grabbed me by the collar and yanked me back up to the top of the stairs. She continued to hit me until the racket broke. She threw the pieces of the racket in my room and yelled at me to go to my room until she told me to come out.

I went into my room and sat on my bed holding my arms as sharp pains traveled from my head down my back. I cried as softly as possible. That night when I undressed to take a bath, I saw all the marks from the tennis racket. Violet-colored bruises were on my arms. With my back to the mirror on the medicine cabinet, I saw deep red bruises all over my back.

As I looked at my back, tears rolled down my cheeks and thoughts filled my head. Was this my fate? Would I continue to get beatings until I turned 18? Would she go too far one day and actually end my life? Why couldn't I be a good daughter? Why did I always seem to get into trouble?

I slipped into the tub of lukewarm water and continued to cry softly so that I would not awaken my mother. My heart was

just as weary as my body and my spirit was broken. I was tired of being beaten.

Lena and I made up a day after the incident. I was trying on one of her blouses when she noticed the bruises on my arms. Most of them had faded from purple to a deep reddish tone. She asked me what happened, so I recounted the event to her. Lena had convinced me to show her mother. I was hesitant because I did not like for people to know that my mother hit me. I was not only embarrassed, but also afraid.

Nearly every day I feared that my life was in danger. I always felt that if I did everything the way my mother directed, I would not be hit. It was not certain what she would do if the neighbors knew of the beatings, so I chose to keep my mouth shut and my bruises hidden.

Lena's mother told me to go to school the next day, show my guidance counselor the bruises and give the counselor the number to my social worker. I contemplated the thought of telling my guidance counselor. If I made it known that my mother hit me, she would be infuriated. The truth of the matter was that I wanted and needed help. I did not want to continue living that way.

Lena was my moral supporter. She initiated the conversation with the counselor, telling her that I had something to show her. I was still hesitant, but Lena convinced me not to be afraid. We closed the door to the counselor's office. I sat my books on the floor beside my chair and proceeded to push the sleeves of my shirt revealing my fading bruises. The counselor was startled. She asked me how I got the bruises.

Before I could say a word, Lena blurted out, "Her mother did this to her."

I confirmed the statement and gave the counselor the name

and number to the social worker who had visited the house a few times. Before the end of the school day the social worker picked me up. At that time I did not know that would be the last time I would see that school, my friends or the school bus that I had become accustomed to riding. I didn't know it then, but that was the day I took my last bus ride home.

Fitting In

There were 10 boys and four girls at the group home. The kids were of various ages. At 11, I was the youngest. I had grown to like most of the kids. The people at the group home became my family. Sharing daily experiences brought about closeness. Everyone hated riding in that tan colored van that seated 15 people and had no tinted windows. It was humiliating to be seen in the van when it was fully loaded with kids. On school days we asked to be dropped off at least a block away.

The less the kids at the school saw me getting out of the van, the fewer questions I had to answer. People would ask questions like, "Who were all those people in that van with you?" "Are those your brothers and sisters? Why don't you look alike?"

I made up a story about living with an uncle who paid for me to ride with a transportation service. Since I was the only sixth grader, I did not have to elaborate on my lies. I was sure that the older kids from the group home received the same questioning from their classmates, but no one ever discussed it.

The food at the group home was a daily topic of discussion. I knew there were people starving around the world, so I really tried not to seem ungrateful for the meals we received. Still, it was hard to eat that baked chicken and mixed vegetables for dinner on what seemed a daily basis. I even think the workers at the group home were tired of serving it to us. The chicken was so dry

that breaking the skin was like chewing leather. The chicken was just as hard to clean from the baking pan as it was to swallow. The mixed vegetables were bland.

When we found out that we were having that chicken and vegetable combo, some of the kids would swear and curse all through the house. "I'm tired of that damn chicken! Why can't we have some pizza or something else once in a while?"

Sometimes we could get the staff to let us have something different. The alternative food of choice for most of us was choke and slides, better known as peanut butter and jelly sandwiches. Those sandwiches were like eating a slice of heaven compared to that dry chicken and mixed vegetables. When the cook went shopping, we would have to help bring in the grocery bags. The bags were filled with more than just chicken and mixed vegetables.

The cook kept most of the snacks locked in the pantry. Some of the boys were crafty enough to get inside the pantry without keys. When we started seeing the boys walking around snacking on granola bars, potato chips and good cereal, the girls made the boys show us how to get into the pantry. Soon everyone knew how to get into locked places around the group home.

The cook soon got smart to what was going on and requested a deadbolt lock be put on the pantry door. The new lock stopped us from the pantry raids, but we knew it wouldn't be too long before someone would be skillful enough to get inside. When that night came, they not only got inside, they took the pantry door off its hinges.

It was after midnight when I was awakened by yelling coming from the boys' floor.

"Fuck you! Fuck you, muthafuckas! I'm tired of this shit! Y'all don't give a damn about me! I'm tired of y'all trying to tell

me what to do!" were the words from a male resident.

The midnight staff worker calmly replied, "You need to set-tle down and get yourself back in bed."

"I ain't doin' shit! I don't give a fuck about them trying to sleep! Y'all niggas wake up! Wake y'all asses up!"

"That's enough! You need to be quiet and let these boys sleep!"

The resident only became enraged. "I told you I don't give a fuck! Don't put yo' hands on me! Don't touch me! Don't touch me!"

"We can take this outside. You a big man, right? You talk like a big man!"

"Get yo' damn hands off me!" the boy persisted.

The staff worker continued to challenge the resident. "I thought you were a man. You talk like a man, cursing all the adults out around here."

"Get off me! Get off me! Muthafucka, I can't breathe! I can't breathe!"

They continued to exchange words for a few moments before waking the other male residents who quickly joined in, yelling, "Get off of him, man! You ain't supposed to be doin' that! Man, you on his chest! He can't breathe like that! Get off him!"

All the residents were roused by the yelling and rumbling. Two other girls joined me at the bottom of the stairs to listen. They soon crept halfway up the stairs to get a view of the excite-ment. About three quarters up the stairs they kneeled down and perched their heads, peeking through the doorway. "That's not right! You're not supposed to be on him like that!" one girl yelled.

I flew up the stairs so that I could see, too. I kneeled down with my elbows bent on each of the girls' backs, so I too could peek through the doorway.

All of the lights were off in the bedrooms. Only the light in the boys' sitting area was on. That is where the action ensued. Nine boys stood facing the sitting area but maintained their distance from the two in the scuffle. The staff member was sitting on the teenaged boy as he lay stretched out and almost motionless with the side of his face buried in the carpet. It was obvious that the boy's 140-pound body could not handle the weight of the 220-pound man.

We were family and we could not stand by any longer watching one of us being hurt.

"Get off of him!" one of the boys yelled, starting a domino effect. One by one and then at once, the kids yelled and screamed. One of the boys knocked over an end table, while another yelled that he was calling the police. The boys started running toward the stairs. We girls stood up and ran back into our rooms.

The event started a riot in the group home. There were usually two staff members assigned to each of the three shifts, but on that night there was only one and there was no way he could handle all of us alone. The home was laden with chaos. Anger and rage provoked the attitudes, as yelling and cursing echoed in the halls. Some of the boys started to turn over the dining chairs. Others were trying to get into the locked staff office. There was no carefulness in trying to pick the lock. Their motive was not only to get in, but also to tear down the door.

The moon shined through the sheer curtains that covered the living room and dining room windows. The boys were running through the house as if it had been set a fire. Some wore tee shirts and pajama pants and others wore only boxer shorts.

I stood in the doorway of my bedroom watching and listening. I did not plan on joining the commotion, even though it had a hypnotic effect. The residents were in a trance, but dam-

aging furniture and breaking down doors did not interest me. I was just hoping that no one would actually set the home on fire.

All of a sudden I heard a loud banging noise that made me jump with its volume. I left the doorway to see what was going on, but the darkness blinded my view. I followed the noise as it had gotten louder and I knew it was coming from the kitchen.

I approached a crowd in the kitchen. Two of the older boys were banging at the hinges of the pantry door, one with a hammer and the other with a tool I could not identify. They banged at the pantry door using the light from the ajar refrigerator door to see. The pantry door was indeed coming off the hinges. Now that was action that I was interested in. I thought to myself that I could probably harbor enough snacks to replace at least a week's worth of nasty, baked chicken dinners.

Once the door was off, every one climbed in. It was like we had hit the snack jackpot. I saw food that I had never seen at any meal we had at the group home. There were boxes of good cereal—the sugary, fruity kind we only got once in a while. There were cookies, granola bars, chips and snacks we only got on very rare occasions.

One of the boys yelled out, "We never get to eat the good stuff like this!"

During the commotion, I was only able to grab a box of cereal and a box of granola bars. The boys were much swifter during the snack raid. With my boxes in hand, I walked back to my room. As I was going into my room to hide my snacks, the front door of the home flew open and two of the bigger staff workers who normally worked during the afternoon shift entered.

"Ay, you kids put all that stuff down! What the hell is going on here?" one of them yelled.

"This behavior makes no sense. Don't you realize you're just hurting yourselves? You have to live here, not us," the other said.

When the kids heard the voices of the other staff, they scurried like roaches do when the lights are turned on. The midnight staff worker must have called the two from the phone in an upstairs office. When he came down the stairs, the three staff members rushed all the boys who were in the kitchen back up the stairs. One of the staff members came in my bedroom as I was pretending to be asleep, lying on my stomach with a pillow over my head. He turned on the light and asked where my roommate was. I told him I didn't know, but I knew she was in the basement with another girl and two male residents. He asked if I knew what had happened. I just told him that when I heard the boys come down the stairs making noise, I put the pillow over my head and went back to sleep. I lay there knowing that if he had come any closer he would smell peanut butter granola on my breath. He turned the lights off and closed the door.

When I awoke the next morning, I was amazed at the way the nighttime had covered the damage that was done to the group home. Tables and chairs were overturned in the dining area. Pillows and cushions from the couch had been tossed around the living room. Streams of toilet paper were throughout the lower level of the home. Holes had been punched in the walls. Papers had been thrown everywhere as if it were the last day of school and children had tossed their papers on the hallway floor instead of putting their refuge in the trash.

The entire house was put on restriction from any outside activities and television for one week. We were also commissioned to clean the house from top to bottom. Repairs were needed for the damaged walls and doors. The fortune in being one of the relatively good kids was that I rarely got blamed for anything. Even though I took part in the disorder, my involve-

ment was minimal compared to the other kids. I was not put on restriction but rewarded for choosing not to indulge in the antics. Not all the kids stood by idly during my praise. They tried to proclaim my guilt, but it might as well have fallen on deaf ears.

There were times when I made a point to fit in with the group. I had my occasional screams of, "I ain't doing nothing around here! I hate this damn house!" I had to show the other residents that I was just like them. The staff could not always protect me, so I had to build a suit of armor to protect myself. Sometimes that suit of armor got me put on restriction, but it was better to upset the staff temporarily than to upset the kids all of the time. If some of the kids saw me getting too much preferential treatment they would definitely make difficult situations for me. I was very mild tempered, but at times I was tempted to show my fighting side.

The other girls never bothered me. My problems were with a small group of boys. Some would play around and joke at my expense. Others would pick fights with me. Most of the fighters were cowards. They were the ones who would always be on the receiving end of the beatings from the older or bigger boys. The only way they felt they could redeem their manhood was to pick on the girls.

One of the biggest cowards in the group home, Gary, always fought girls. He decided to try me one night on the way home from a group outing.

"Gary, stop touching me! I told you to keep your hands off me! Mr. Cross, tell Gary to stop touching me," I yelled with annoyance.

"Leave her alone, Gary, before you get put on restriction!" Mr. Cross answered.

"I ain't even touchin' her! Keep lying on me, Taneshia, and I'm gonna smack you!" Gary replied.

"You ain't gone do nothing with your black self!" I said.

"Keep talking and see what I do!"

"Why don't you leave her alone, you always messing with somebody," one of the girls said.

"Because he's a little bitch!" I added.

"Hey, y'all need to cut that out right now. I'm gone put this whole van on restriction," Mr. Cross said.

"Who you calling a bitch? Bitch! Wait 'til we get out this van, I'ma jack you up!" Gary threatened.

"What's up, what's up, we can go right now you black sissy! Ain't nobody scared of you. What's up?" I taunted.

The van was coming to a stop in front of the home and Gary jumped out the front passenger door before the tires stopped rolling. My heart was beating so fast that I thought it was going to come out of my shirt. My body did not want to get out of my seat but my head was telling me not to back down. I was praying that Mr. Cross would somehow get Gary inside the house and away from me. He kept telling Gary to go inside but Gary was too excited. Mr. Cross wasn't allowed to use physical force with Gary unless he was being physical.

Gary was bigger and stronger than me. He was sure to give me a beat down because I had never engaged in a true punching match with a boy. I used to fight with my uncle when I visited my grandmother, but that was different. My uncle knew not to cause any real physical harm, and deep down I knew he was never going to hurt me. But that day I knew that once I stepped out of the van door, I would have to start swinging, wild and fast. My objective would be to keep him from hitting me. My roommate got out the van before me and stood right into Gary's face.

The second tallest resident in the house, she towered over him. "You better not touch her!" she yelled.

"What? I'll beat your ass, too!" Gary shouted then backed away.

"You ain't gone do nothing, you fat coward!" she yelled back.

I felt slightly relieved that my roommate did not want me to face him alone. Gary was intimidated by her height and attitude, as were many of the boys who were shorter than she was. When I stepped out the van door, I saw a circle of people who were waiting to see some action, much like the groups I'd seen during playground brawls during my elementary school days.

The other residents came outside. Some of them were wearing their pajamas. A staff member yelled for them to get back inside, but they were too eager to see a fight. The front of the house was dark except for the streetlight that seemed to beam down on us like a spotlight. Mr. Cross blocked Gary from me and my roommate. My roommate blocked me with her height, though I was wider than she.

"This ain't got nothing to do with you. This is between me and that bitch!" Gary had to jump up so that he could yell over Mr. Cross' shoulder.

"You ugly, black bastard! You ain't gone do a damn thing to me!" I yelled back over my roommate's shoulder.

I had to save face in front of all the residents because if I showed weakness, I would be teased and taunted by the rest of them until the end of my stay.

"Come from behind her and say that shit! I bet you won't," Gary yelled.

I walked from behind my roommate and yelled back, "Ain't nobody scared of you! What's up now? What's up now?"

"Gary, get yourself in the house right now!" Mr. Cross

hollered, still blocking Gary.

After a few moments, Gary backed away as if he were doing as Mr. Cross had told him. Everyone followed Mr. Cross and Gary toward the steps of the group home, but Gary turned around and ran back to my direction, screaming and waving his fists. He swung at me and I felt the air whiz past my face as I jumped back to avoid the punch. The swing knocked him off balance. With all of my force, I pushed Gary and knocked him to the ground.

Mr. Cross ran back toward us and grabbed Gary. Assuming that Mr. Cross' grasp had Gary well confined, I proceeded to act like I was a crazy person.

I screamed, "Let that punk go! He wants to fight girls so bad! Let that punk go so I can blow his mouth out!"

The other staff on duty ran down the porch stairs and grabbed me to keep me from sucker punching Gary while he was being held. The staff member told me to go inside to my room and I complied. I was much easier to handle than Gary. I didn't want to fight anymore.

Mr. Cross stayed outside with Gary for a while and the other boys went upstairs. Mr. Cross was trying to calm Gary down. I think Gary liked the attention. Most of the time when the residents acted out, it was because they wanted more attention from the staff.

Later I heard Gary and Mr. Cross walk inside the house and up the stairs slowly. Gary's eagerness to fight had subsided. I didn't know why he lashed out at me, but I knew I would never have to worry about being harassed by him anymore because tonight I had shown him that I was no punk.

For a while, I did not have to worry about any of the male residents fighting with me. This was especially true after Marlon

came to live at the group home. Marlon was the brother of one of the girls at the group home. He had a commanding presence and was tall and handsome. Marlon always had something funny to say. The rest of the kids were either afraid of him or wanted to be like him. Most of the girls had crushes on Marlon. Unfortunately for them, Marlon had seemed to take an interest in me.

He would hang around the girls' room conversing with his sister and me in the hallway. He took every opportunity to sit by me in the dining room, in the van during outings, or in the TV room. He would come to my defense when necessary, offering me the same protection he'd give to his sister.

Marlon started asking me for hugs. I gave them without hesitation. I liked the attention and I did not want it to stop. He was so funny and cute that it was hard to resist him.

He asked for hugs more frequently and his affection seemed to intensify. We started to give each other kisses on the cheek. I did not think much of the kisses. They seemed harmless.

Marlon visited my room more often, sitting next to me on my bed and making jokes. The staff did not seem to mind that he was around us. It was probably because his sister was around also. But after nine o'clock, he and the other boys were restricted from going to the girls' area. That was the time we would take our showers and prepare for the next day.

Sometimes a couple of the boys would find a reason to come in our area, but the girls always knew what they were up to. They were trying to sneak peeks at us while we were in the bathroom. We had a lock on our bathroom door until someone broke it off, so we took shifts watching the bathroom door while one of us was inside.

Once, I caught three of the boys watching me through the bathroom window while I was drying off. The curtains to that

window were pink and sheer. I let out the loudest scream and the rest of the girls ran in the bathroom with a female staff member. The next day, a new window was installed. It was thick and you could only see shadows through it. When Marlon found out about the incident he badgered as many of the boys thought to be suspects until they broke down and pointed out a culprit. Marlon smacked the boy around until the staff broke up the fight.

From that point on, Marlon started hanging around me even more. He told me to tell him whenever someone was bothering me. The other boys would only talk to me when he was not around. He began to whisper things in my ear. At first I thought it was funny, because he was "capping on," or making fun of one of the kids. But he stopped capping and started saying things to me that I did not understand.

He would say, "I wonder how you feel."

I thought he was joking so I would just laugh it off.

Then he started to say things like, "I bet you feel warm and wet on the inside."

I asked him, "On the inside of what?"

He replied, "Between your legs."

I felt uneasy about the way he had begun talking to me but I liked the feeling of security he gave me. I was confused. I wanted attention, so I did not tell anyone about the things he would say or the ways he began to touch me. He started coming to my room when I was alone. He would push the door far enough for him not to be seen by anyone walking by.

My bed was behind the door. He would sit down next to me on the bed and rub my legs beginning at my knees and traveling up my thighs. When he reached between my legs to touch my vagina, I would push his hands away. Even through my pants, I could feel his fingertips. My body had never tingled the way it

did when he touched me. The feeling was strange and I did not think it was right for me to tingle that way.

Marlon began to show his impatience with my resistance. It was almost like he was angry with me. I did not want him to be angry, but I was not comfortable with the way he touched me. Marlon took as much rejection as he could stand. He started keeping company with one of the older girls. I did not care as much as I thought I would. He had started to become more of a nuisance than a friend. I thought I was rid of Marlon until he paid me a visit one night.

"Are you asleep? Psst, psst." He tried to awaken me with a low voice that was near a whisper. "It's too hot in here for you to be sleeping. Taneshia, are you asleep? Girl, you hear me. Oh it's like that, huh? Nee, Nee. Hey, Nee."

He fluttered his fingertips around my neck. "Does that tickle?" he asked.

"What are you doing in here? You know Midnight will put us on restriction if he finds you in here," I said. Midnight was what we called one of the midnight staff members.

"Midnight's fat ass is sleep," Marlon replied.

"Would you please leave, Marlon?"

"I want to be with you, Nee Nee."

"No, I think you need to leave. Leave before we get in trouble," I said speaking in a voice that was louder than a whisper.

"Come on. Come on Nee, let me just lay down beside you."

"No! Marlon, get out." I was becoming more than a little agitated as I continued to urge Marlon to leave.

"Okay, okay. I'll leave after you give me a hug."

"I'm not giving you a hug."

"Come on, I promise I'll leave. Just give me a hug."

"All right." I started to sit up to oblige his request.

"No, don't sit up. You can give it to me right there. Look, I'll come to you."

"You do not have to lie on top of me, Marlon."

"Can I feel you? Just let me put my finger inside you."

"Marlon! Get off of me!"

"Open your legs, Nee Nee. Stop being like that."

"Marlon, Get off of me! I'm not playing with you!" I yelled.

I tried to push him off, but the harder I fought, the heavier he became. Marlon finally laid his entire body atop mine almost smothering me. It felt as though my chest was caving in. My arms were pinned to my sides.

"I can't breathe. I can't breathe. You are too heavy, get off of me."

"Shhh. Be quiet."

"Marlon, stop it!" I screamed.

"You'd better stop screaming," Marlon demanded as he pressed his body down further onto me.

"Marlon, please don't do this." I was begging.

He kept his hand tightly on my mouth, muffling the sounds that tried to emerge. With his one free hand he pulled my night-gown up to my stomach. He forced my legs apart by jabbing at them with his knees and thighs. When my legs were apart he put both of his between them. I felt him fidgeting below my waist. His hand was between my thighs. Marlon pulled one side of my underwear to the other, uncovering my vagina. He put his finger inside me. Through his fingers that covered my mouth, I begged him to stop.

"Shut up. If you bite my hand I will slap you," he threatened.

"Ooh, you feel so warm. You like the way my finger feels? Ooh, let me put it in. Let me slide my long thing up in you."

He was not paying any attention to my cries. I knew he felt

the tears fall from my eyes down his hand. My tears did not stop him. He pulled his finger out and I felt him fidgeting again. After a few seconds, I felt him thrusting himself inside me.

"Don't cry. I won't hurt you. Stop crying. I promise it won't hurt."

"Mmm," he continued. "Damn, you feel good. Don't you like it? Don't it feel good to you? Get it wet for me. Ooh. Ooh, Nee, Nee. You got a long tunnel. Oh, I think I'm bout to come. Ooh, nut, nut, nut. Damn, girl."

My tears continued.

"You're still crying? Stop crying? You know it didn't hurt. Stop being a baby."

The pain penetrated my pelvis. I realized that he would not get up until he was finished. I lay there releasing my spirit from my body. I closed my eyes and imagined that I was floating in space. I thought that if I pretended I wasn't there, then I wouldn't be having the horrible experience.

"You better not tell anybody. I gotta get out of here before Midnight wakes up," Marlon whispered.

When he finally got off of me, I pulled my nightgown down and curled up on my side into a ball. I pulled my knees up to my chest and wrapped my arms around them and held them together. I felt so ashamed and dirty. I wanted to cleanse myself but if the midnight staff heard the shower running that late I would have been put on restriction. I just held my body tight and cried myself to sleep.

The next morning I awakened as soon as I saw daybreak. I took a painful walk into the bathroom. I turned the hot water on full blast into the tub, steaming the mirrors and faucet heads. I sat in the tub replaying the incident in my head. I constantly wondered what I could have done differently. Why didn't I try

harder to stop him? I should have screamed at the first sight of
him. Maybe the midnight staff or the other girls would have
heard me.

It was too late. There was nothing special or wonderful about
sexual intercourse. I just felt that a part of me had been stolen
and I would never be able to get it back.

I felt distant from everyone. I did not speak of the incident
to anyone because I felt ashamed and afraid. Some of the staff
asked me if something was wrong or if I was sick. I just told
them that I was okay and that I wanted to stay in my room and
read my books.

We had to leave our doors open unless we were changing
our clothes or asleep. Some of the boys came to my door giggling
and pointing at me. I thought they were just being silly as usual.
I did not pay them any attention. I heard Marlon and another
female resident talking and laughing down the hallway. She had
walked into her bedroom across from my door. Marlon walked
over to my doorway and smiled at me. I got up and slammed my
door in his face. I heard one of the staff members ask, "What's
going on here?"

Marlon replied, "Nothing, I didn't do anything to her. She's
just acting funny."

My door opened and the staff asked me what happened. I
just said that Marlon was bothering me. The staff told me to
keep the door open.

It was only a short time before word of the incident got out.
The group home social worker was asking me about the alleged
sexual encounter. I just looked toward the ground and denied it.
She assured me that nothing would happen to me if I told her
the truth. I continued to stick to my original story. I thought
that if I blocked it out of my mind and out of my thoughts that

it would not be real. I often felt that way about most things. I remained silent despite the social worker's many requests for information.

Mrs. Sherry was the director of the group home. She came to my room one afternoon and closed the door behind her. She was a grandiose woman who was always dressed professionally in a business suit. None of the kids in the group home ever cursed, talked back or lied to Mrs. Sherry.

She hugged me. She was the closest image I had of a mother. She looked in my eyes and told me that if someone hurt me she wanted to know. She asked me if Marlon had forced himself on me. I looked at Mrs. Sherry. Her eyes were filled with concern. Before I could shake my head she said, "I want you to tell me the truth. Don't be afraid." She held my hands in hers.

With more hesitation, disgust and anger I recounted what happened on that night to Mrs. Sherry. Within the hour, police had shown up at the group home. Marlon was taken away.

Marlon's sister was very upset. I think she was the only kid at the group home who was. Some of the boys were relieved with Marlon's departure. They no longer had to fear Marlon or feel forced to act under his delegation. With Marlon gone, there was no need for me to feel afraid. He would never force me to do anything ever again.

No One Else's Child

Soon after I'd turn 12, I was introduced to a couple who wanted to foster children. Lucky me! I was a candidate. I did not want to be a foster child again.

Before I was a resident at the group home, I lived with a foster family. They were an older couple in their late fifties to early sixties who had no children of their own. Their house always smelled like medicines and arthritis creams. The couple couldn't relate to me at all.

The woman of the house ran it smoothly. Her husband was retired and sat in his easy chair watching sports and old movies on their floor model television for most of the day. He rarely moved from his spot. The wife was retired also, but she was much more active than her husband. She participated in functions and events at her church.

While I stayed with them, I had to attend all the functions and events as well. I did not mind. I was not in school, so church was the only time I got to see children my age or adults who were younger than the foster parents. I used to sit in church and fantasize about being with the younger couples I saw. Why did I have to be with such an older couple? They were nothing like anyone I knew. They were older than my grandmother and acted twice as old as my grandfather. I had never been as bored in my life as I was when I was with them. Even the way she dressed me

was old fashioned. My social worker had not gotten my clothing from my mother, so the foster mother picked up some clothing for me.

I tried to be as appreciative as I could be, but how could a woman who was approximately 60 and only wore polyester pants without buttons or zippers shop for a preteen girl without taking her along? My fashion needs were not met by a long shot.

Even though she lacked fashion sense, the foster mother was really a sweet woman and she would try to teach me to cook. I stayed with her the majority of the time. The foster father did not accompany us to church or anywhere else. I did not have much interaction with him, but when I did, it was always a strange experience.

The first day I arrived at their home, they each gave me a hug. I was not receptive to being affectionate with people I hardly knew. Later that day, I was sitting across from the foster father on their living room floor, answering questions about my school, my grades and my family.

I didn't know how questions about my feet became part of the inquisition, but they did. He asked me if he could see my feet. I thought it was a strange request, but I obliged. He grabbed my foot and started to rub it. I felt a tingling sensation. I pulled my foot away, got up from the floor and found the foster mother in the kitchen. I stayed with her while she made dinner, but I did not say anything to her. I did not know what was going on. I just felt strange.

During the next weeks, I tried to stay a considerable distance away from the foster father. Sometimes he was unavoidable. One day his wife went to the store, leaving me behind with him. He told me to come from my room into the living room where he sat watching television. As I walked into the room and tried to pass him, he grabbed my arm. He pulled me into him and I

tried to yank myself away. He told me not to be afraid because all he wanted to do was love me. He held his arms tightly around my waist. He started kissing my arm. The wetness I felt from his lips turned my stomach. I pulled away with all my might, pushing him back in his chair. I ran back into my room barricading the door.

When the foster mother returned, I stayed in my room. I did not want to come out. I knew I could not tell her for fear that she would not believe me. I asked myself, "Why would she believe me over her husband?" The next day I called my social worker. I told her what had been going on.

She was furious, but not at the foster father. "Taneshia! I have bent over backwards for you. You told me that your mother started beating you again and I came for you. I tried to place you somewhere nice and you're trying to mess that up. You better start behaving. Don't let me hear that you are causing trouble," she snapped at me.

I really felt helpless. The one person who was commissioned to care about my situation no longer cared. I thought about a counselor from the shelter that I had been placed in the first time I was removed from my mother. She had befriended me. She was my last hope of helping to get me out of the situation with my foster father.

I decided to give her a call and tell her everything. She advised me that the only way I could get out of that situation was to make the conditions there unbearable. She told me to rebel. They would have no choice but to remove me.

Taking her advice, I began my mission to get kicked out of that house. I yelled at both parents. I stayed in my room most of the time and would not come out for meals. The mother would try to make me go to church with her and I would scream and refuse. I stopped doing my chores and became unruly. I was not

ashamed of what I was doing. I felt as if I were fighting for my survival.

After three weeks of putting up with me, the elderly couple felt it was time for me to leave. My social worker was called to come for me. When she arrived, she told me that she was furious with me and that she could understand why my mother would hit me. Her words were hurtful because what my mother did to me was wrong. What that foster father did to me was wrong. My social worker made it seem as though I deserved the things that had been done to me.

I was placed in the group home and a few years past before I was questioned about the foster home. I was visited by two police officers—one in plain clothes and one in uniform. There was also an attorney. The attorney asked me about my experiences with the foster parents. I told them everything that went on in the home. The attorney told me that he needed my help to prosecute the foster father. Five-year-old twin girls had been placed in that home after me. He sexually molested them as it was revealed in the girls' therapy sessions. I was sickened by the thoughts of that old man touching me. My skin started to crawl as I thought of him touching those poor, defenseless little girls.

"Yes, I will help you," I told the attorney.

When I went to court I saw my former social worker in the hall. We were almost equal in height. With one of the group home's staff members by my side, I was also equal in confidence.

I looked her in the eyes and said, "I told you. I told you what he did and you did not listen. Now look what he has done to those little girls. Maybe you'll listen to a kid next time." She just looked away with no response.

After that incident, I could not handle the thought of being placed in another foster home. There was no need to change my situation. I felt that since my mother stopped being concerned about me, I did not need a new mother. I never had a father and was not looking for one of those, either. But because I was such a "good" child, the social workers believed that I deserved to be in a more traditional family setting.

A new foster couple had been chosen for me. I met with them several times with the supervision of the social worker and then unsupervised visits on the weekends. The couple seemed mismatched. The wife was in her late twenties and thin. She wasn't the most attractive woman, but she was not ugly. She wore tight fitting clothes to show her curves. The husband was in his middle forties and wore a textured afro. He was shorter than she and had a pudgy frame. He worked in an industrial plant and she was a homemaker. I could tell that the husband had the say in the way the house was run. She seemed very submissive and tried to keep him happy by being a ghetto version of Mrs. Cleaver in the "Leave it to Beaver" television show.

They had been married for a few years and had not been successful in conceiving a child. Fostering children had become their alternative. As they got to know me, they were excited about bringing me into their home. I can't say that I shared that excitement.

Reluctantly, I had to leave the group home and join my new foster parents. They lived at the border that separates the city of Detroit from the city of Grosse Pointe. Grosse Pointe was a wealthy community. Some say it was made up of people who had old money or old people who had money. Either way, Grosse Pointe contained some of the biggest and most beautiful houses that I had ever seen.

On the other side of that border were houses that obviously

did not belong to wealthy people. The houses that spanned our three-block street were fairly well kept and had manicured landscaping. The house my new foster parents lived in was probably the best looking one on the street. It was certainly cleaner than the group home, but that did not matter because I longed to be back with my group home family.

The style of the people in the east-side neighborhood was different than what I had witnessed living with my mother on the west side of Detroit. Just about everyone on the block wore a Jheri curl, a curly hair style that required the hair to be rolled and set with curl rods and maintained daily with activator. The Jheri curl was notorious for damaging the collars of the clothing of all who dared to wear one. The foster couple wore Jheri curls. The furniture in their house, like the furniture in the homes of kids I visited in the neighborhood, had a hard, plastic covering. The carpet in the house was dark blue and had plastic runners to prevent stains.

My bedroom was nice. I had a complete bedroom set with dresser, nightstand and full-sized bed. I had a small 13-inch black and white television that did not get very good reception, but it was still a television in my own room. Being there helped me to remember what it felt like to be an only child again. I got quite a bit of attention because I was their first foster child. After about three months, the foster couple received twin foster sons.

The twins were eight years old. One boy was smaller than the other and was also a bit slower. They did not look like twins at all. As a matter of fact, their only similarity was that their names rhymed. One boy was very sweet and mild mannered. The other was mischievous and most of my memories are of him being scolded and sent to his room. They were my little brothers. I had never been the eldest before, so it was fun bossing them around. It wasn't so much fun to baby-sit. Overall, life there

was okay, especially after I got enrolled in school.

I played the role of an eighth grader for four weeks until the school officials found out I was really in seventh grade. The foster mother just signed me up for the grade she thought I should have been in according to how old I told her I was. I was always self-conscious about my size. When I met these new foster parents and saw that I was bigger than my soon-to-be foster mother, I proclaimed myself a year older. There was no way I could be a pre-teen and be bigger than a twenty-eight-year-old woman.

My mother instilled the consciousness of my size early in my childhood. She would make comments about me being overweight and often compared me to my friends by asking me, "Why can't you be small like your little girlfriends?"

Being around strangers gave me the luxury of compensating for my weight by lying about my age.

When I was taken out of the eighth grade class and put into the seventh grade class, the experience was humiliating. It was better if the eighth graders thought I had been put back because I was slow than to know I had simply lied about my age. After a short while most of them forgot about me. I was really easy to get along with so I had no problem getting to know the kids in my new class. I had so much practice meeting and getting to know new kids and making them my friends quickly, but I never got a chance to really hold on to any friends. Soon names were forgotten and faces just became familiar. This was also true of the foster families I was placed with and the people who lived around us. When I was comfortable within an environment, I made the most of the arrangements.

I had no idea how temporary that arrangement was, but I felt I wouldn't be there long enough to graduate from junior high. I enjoyed the people who lived around us and I had a boyfriend who stayed three houses down from me. His first name was

unusual for a black boy in the hood. His name was the same as a past president's. No one liked to call him by his first name, probably because it sounded too weird. We all called him by his nickname, Shoobie.

Shoobie was so cute. It was a good thing I didn't wear high heels at that age, because he probably would have been shorter than me. The girls in the neighborhood who didn't like me were very envious of me and Shoobie, but it didn't bother me.

We could not really go out together because we were kids, so most of our dates were Saturday meetings at the skating rink. The skating rink was a popular spot. The kids we knew were always in our faces, so it wasn't like we had any time to ourselves. Still it was nice to have a boyfriend.

At the house, there was an enclosed porch. Shoobie would sit and talk with me at night until my foster mother would tell me it was time for me to go into the house. Shoobie was a perfect gentleman. He never tried to touch me in any of the forbidden places. The forbidden places were anywhere below my neck. We would kiss on the lips but never open-mouthed. I liked Shoobie because he was sweet and he made me feel special. I liked my friends and living with my foster family. Things seemed to be going well until changes started to occur.

It was almost the end of the school year. Everyone was looking forward to the summer break. Kids younger than 14 were too young to get a summer job. For us, the summer was filled with days of getting up late in the morning and playing or exploring the neighborhood until night fall. After 9:30 p.m., I was allowed to be outside as long as I was in front of the house where I could be seen.

I was looking forward to the summer. My birthday was coming up in July and I would finally be a teenager. My foster mother sometimes teased me about being a pre-teen but soon that would

be all over. The summer definitely looked promising until there was talk about another foster child coming to live with us.

It did not bother me having the twins as foster brothers because they were too young to hang around me. They had so many things going on that I didn't see them much. They had therapy sessions, tutoring and weekly visits with their sister, who was also in foster care. I guess my foster parents had been approached with the idea of bringing the sister, who was two years older than the twins, into the home so that all of the siblings could be together.

The sister started to come over to the house for daytime visits that soon turned into weekend visits. The girl was a tiny little thing. She almost looked like she was in pre-school, but she was ten. She was very cute and very sweet. I liked her but did not like the idea of having to share my room with her. My full-sized bed would have to be traded for twin beds. My drawer and closet space would be decreased. I was not happy with the sacrifices, so I started voicing my opinion. (My opinion. Yeah right, I had no opinion.)

For about two weeks straight, my foster mother and I were not getting along. I talked back to her and was slow to respond to her requests. When my foster father started yelling at me for giving his wife a hard time, it had no effect.

"You're not my father and you can't make me do anything!" I'd yell back at him. I would not come in the house when I was supposed to. I'd complain about doing chores and my reasoning would be that since I wasn't there to mess it up I should not have to clean it up. That behavior did not go over well with either of my foster parents. The couple began making arrangements for me to leave their house. The luxury of having foster children is that when they "break," they can be traded for new ones. It is not like living with your real family and being forced

to work through the difficulties.

About three weeks before my birthday, I was told that I was going to leave. I was not remorseful. I was not apologetic and did not beg to stay. I simply packed my things and said my goodbyes to the people in the neighborhood. I would attempt to keep in contact with some. Of course, Shoobie was one of those people. I really hoped that we would stay in touch. I was going back to the group home, and it seemed as though Mack and East Grand Blvd was a million miles away from the border of Detroit and Grosse Pointe.

I knew it would be impossible to see Shoobie because he wasn't old enough to drive. Getting the group home staff to drive me back to his neighborhood would be near impossible. He would just have to become one of those familiar faces I collected in my mental photo album.

Return to the Familiar

Maybe I was crazy, but I was elated about being back at the group home. I had missed some of the staff and most of the kids. Given all of their dysfunction, they were still my family. Being in that foster home for a short period was like being on vacation. It put me in a different environment with new people who I soon said goodbye to.

Upon my return, I realized that not much had changed. The home appeared to be even more run down than before. On the inside, you could definitely tell the destructive activity of my surrogate brothers and sisters never ceased. Doors had been kicked off the hinges and the couches in the sitting areas leaned to one side as a result of kids jumping on them.

Fortunately for me, I had not been replaced by another girl, so they could accommodate my return. I roomed with one of the other girls. It was always difficult to room with someone new because you never knew if you'd end up with an unclean person who'd leave dirty sanitary napkins on the floor or a psycho who would watch you sleep. You never knew what a kid experienced prior to being placed in a facility like the group home. No one talked about the psychological effects someone's experiences could have on behavior, but I knew enough to keep my guard up until I found out where someone's head really was.

Faces had changed since I was last at the group home. There

was always turnover with the staff. The turnover rate was rapid for most new staff members. Some we hated to see go. Some we never had a chance to like. There were always a few that we residents were fond of. They were the ones who interacted with us. They never made it seem as though the paycheck was the only reason they showed up. There were the ones who made me laugh, taught me how to be a lady and encouraged me to do well in school. Then there were my "crushes." The group home was mostly male populated, so there had to be more male than female staff members.

One male staff member was T.J., and I was completely in love with him. T.J. was 24 years old and single. He stood about six-foot-three inches tall. His skin was smooth and rich like black coffee with a little cream stirred in. His eyes were the color of chestnuts. He wore his hair cut low and faded to the nape of his neck. His body was long and slender, but he was not skinny. When T.J. wore short-sleeved shirts, I could see his muscular biceps peek from underneath his sleeves. His legs bowed out slightly and he walked upright and proud. His smile made my face light up like a Christmas tree. He definitely had the key to my adolescent heart.

Sometimes I would ask him, "T.J., will you marry me when I grow up?"

"I'd be honored to marry you," he'd reply.

He often worked afternoon shifts as part of the staff we residents spent the bulk of our time with. They were responsible for making certain our chores and homework were done and that we were properly prepared for the next day. They were also the staff members who enforced proper hygiene the most.

At times I would ask T.J. for hugs before I went to bed. I only asked when he shared the shift with certain staff members, usually other males. It wasn't that hugging him was so wrong, but

physical contact between residents and staff was not strongly encouraged unless necessary for restraining purposes. The hugs that T.J. and I shared were innocent. Despite my marriage proposals, he thought of me as a sibling because he called me "little sister." I accepted it, but in my mind I would go after him as soon as I turned 18.

I was not the only one who was fond of T.J. All the residents liked him. He was probably the coolest of the group home staff. I never saw T.J. get angry or raise his voice. All of the residents respected him—even the ones who thought they were the true definition of "bad."

Shortly after we moved into a new group home, T.J. found another job and left the group home, it was a sad time for all of us. I shed a few tears on his last day when no one was watching. He was a special person who made me feel special and protected. I would always appreciate him for that.

Jasen took the place of T.J. as the "cool" staff member. Jasen was the type of adult who seemed as if he wasn't really ready to be an adult. He was like a big kid. All of the residents identified with him. He pulled pranks on us and told jokes at the residents' expense. Needless to say, we all liked Jasen. He also knew when to be stern and authoritative when situations called for it. Jasen had a commanding presence that warranted respect. He towered over everyone in height. His head and body were square like a brick wall. He was not fat, but thick. His belly stuck out just enough for someone to see it when he wore snug tee shirts.

Jasen always wrestled with the boys. His contact was a lot less physical with the girls. He would push our shoulders slightly or tug at our shirt sleeves. He was notorious for pushing us out of a doorway and slamming the door in our faces as we turned

around to say something. It was never unusual to hear someone yell out "Jasen, you play too much!" before slamming a door.

Collectively, we all had a special relationship with Jasen. Though he often worked the afternoon shift, occasionally, he would work a double and assist the midnight shift when they were short staffed. At bedtime, sometimes Jasen would go to each of the girls' rooms and say goodnight, but it was never a simple "goodnight." It was accompanied by some playful or taunting act. He would throw a pillow at us or a piece of clothing that was lying around. All of the girls got the same treatment, but there were times when Jasen seemed to interact more with one of the female residents, Meeko, than anyone else.

Meeko had a bad attitude. No one really liked to be around her for too long. She was 15 and the most developed of the four girls. It almost seemed as if she wore a permanent frown. Meeko got into shouting matches with the staff, but with Jasen, the shouting matches were different. She never cursed at him like she did with the other staff. Instead she would yell and pretend to slam her bedroom door in his face. He would always catch it and walk into her bedroom saying something like, "Girl, what's wrong with you?" He would slam the door behind him.

Those episodes took place mostly at night, right before bedtime. Jasen would be alone with Meeko in the bedroom with the door closed for minutes. Neither the staff nor residents ever said anything because no one was curious enough to want to know what was going on in there. Most people probably thought that Jasen was being silly as usual.

For the Fourth of July holiday, most of the residents went to their families' houses for the weekend. Some of us had grandparents, uncles, aunts, former foster parents and, in some cases, parents who we were allowed to visit on weekends. The group home staff would take us to our destinations and pick us up at

the end of the visits.

On that holiday weekend, Meeko decided to run away from the group home. During the ride back to the group home, my roommate and I were informed that she had left. We had a feeling that Meeko did not leave empty handed. As soon as we got to the front door, my roommate and I flew up the stairs with our tote bags bouncing on our backsides. We got to our bedroom to find the door open, when it should have been shut and locked.

It was not hard to break into the rooms. When my roommate and I locked ourselves out, we picked the lock with the flat end of a fork, spoon or butter knife. That had to be the way Meeko got in.

When we walked into our room, all of our suspicions were confirmed. My roommate and I shared a closet, but I only kept a few things in it. I had an upright storage locker like the kind in school hallways. Our maintenance man let me use it for extra space. I was able to keep one half of it secured with a combination lock. I kept most of the things I deemed as valuable in the locked portion of the locker. It contained my portable boom box, a pair of roller skates, some gym shoes, a few items of clothing and some money. I stuffed as much as I could inside that locked half.

I left quite a bit of clothing in the unlocked half and that's what Meeko took. She took some of the new clothes that were purchased for my big high school debut. I could not understand why she had stolen my things; she could not fit them. I was at least four sizes bigger than she. Meeko hit my roommate harder than me. She had stolen just about every item of my roommate's clothing that she could fit.

My roommate and I took it upon ourselves to rectify the situation. We knew Meeko would occasionally sneak away from the group home to see a man who was a drug dealer and lived two

blocks from us. That night my roommate and I ignored the staff's instructions not to leave the house. Either one of us could have easily beaten Meeko in a fight, but that night we would deliver an unforgettable beat down as a team.

We walked onto the porch of the man's house. It was dark. The only light came from the porch light on the house across the street. My heart was beating fast—not from fear but with vengeance. I banged on the door with the side of my fist while my roommate rang the doorbell. After a few minutes, the man came to the door.

I yelled out, "Is that bitch Meeko here?"

The man opened the door and yelled out, "She ain't here! Y'all betta take y'all young asses home before something jumps off!"

My roommate yelled back, "We ain't goin' nowhere until we see that bitch!"

I could not let my roommate stand up to him by herself. We were a team. We had to stick together.

I yelled through the door, "Meeko bring your black ass out here!"

One of the staff from the group home pulled up behind us in the van and demanded that we got in. We had to choose between getting in the van or being locked out of the house and written up as A.W.A.L. (away without authorized leave). Neither of us wanted that. We decided to end the battle. We got inside the van feeling defeated and victimized.

I hated that Meeko took my new outfits. It was important to me to look good for my first year of high school. The new school year was especially important to me. Being in high school meant that I would no longer be viewed as a kid. I was on my way to becoming an adult. Adulthood meant no more foster care, group

home staff or group home kids. That year began my countdown to freedom from the social service system. I was excited because I was also being viewed as a young lady instead of a little girl. I could finally wear my hair in a hairstyle fit for a teenaged girl. For the years I lived in the group home, I was required to either keep a plain hairstyle like a mushroom or pull my hair back into a ponytail; nothing too mature. The female residents were able to go to a hair stylist. We had standing bi-monthly appointments. We would all go to "the salon" that was really the basement of our stylist's home. She was good. She maintained my hair well. It stayed healthy and long. "No perms, no cuts until you become a teenager," the hairstylist would say to me. She held strong to that statement until I was approaching my fourteenth birthday.

When that time came, I wanted all my hair cut off. The other girls in the group home all had short hair. I wanted to be like them. Going short was too extreme for the hairstylist and she refused to cut my hair short. She did cut it in a shoulder length "bob" style. I was satisfied as long as I did not look like a kid. I was not a kid anymore.

Everyone seemed to like my new hair style—especially Jasen. He frequently made the comment, "So you think you're a little woman now? You're still silly." Jasen could always make me laugh no matter the circumstance.

Secrets and Betrayal

There was a time I was really upset and was crying in my room because my mother cancelled her visit with me. She did not even call to tell me that she wasn't coming. I don't know why I expected anything different from her. With the exception of our occasional unauthorized visits, my mother had been nearly non-existent for at least three years. The social workers had no idea that we had been in contact since I was removed from her custody three years earlier. But once all the group home "bosses" left for the day, only the afternoon staff was left. They were usually more lenient than the staff on the other shifts and allowed me to visit with my mother on the porch, but never inside of the group home. That was probably how they kept themselves from being held liable if anything unexpected were to happen.

Most of the male staff who saw my mother liked the way she looked. Some would welcome her visits more than I did. On the day she didn't show up, it had been nearly a year since I'd seen her. I knew that she had a hard time keeping her word but an easy time breaking her promises. This time was harder because it was close to my birthday. The group home staff usually did what they could for residents' birthdays. All of the kids appreciated their efforts, but deep inside, we really wanted to spend birthdays with our relatives, especially our parents.

Jasen tried to comfort me when he saw me crying. He came to my bedroom to check on me because he hadn't seen me for a couple of hours. He sat next to me on my bed and put his arm around my shoulders. As he put his hand on my cheek, I rested my head on his chest. Jasen was so much taller than me, that his shoulder was too high for me to rest my head on. I guess he sensed that telling his usual jokes and being silly would have been inappropriate. As he rubbed my shoulders, tears rolled down my face, moistening his shirt.

"What's wrong, Taneshia? Did someone do or say something to you?"

I remained silent.

"Come on, you know you can tell me. You know you can trust me." Jasen continued trying to find what was troubling me.

I just told him that I'd be okay. I felt safe with my head on his chest and his arms wrapped around me. His chest felt hard and his cologne smelled like the pleasant aroma of evergreen trees at Christmas. I liked sitting there with Jasen. He made me feel like he sincerely cared about me.

Jasen touched my chin and pulled it upwards so that I could see his face. He took off his square-framed glasses, looked me in the eyes and said, "I care about you, Taneshia. I don't like to see you hurting. I won't hurt you." Jasen grabbed me with both arms and hugged me tightly.

As his embrace loosened, I started to pull away, slowly. Jasen leaned into me and pressed his lips on my cheek. His kiss was gentle. He kissed me once more on the lips before releasing his embrace. I sat there staring into his eyes as he told me again how much he cared for me. I didn't resist his kiss, although I was surprised by his actions. He hugged me again and I hugged him back. We were still embraced, but our bodies were far

enough apart for us to look into each other's eyes. We both leaned in to kiss on the lips. He pushed his tongue into my mouth, moving it around.

I had only known how to "French" kiss with boys my own age. I just sat there with my mouth open, allowing Jasen to chase my tongue around. I did not feel any sensation from doing this, but I could not believe I was doing it with him. He finally pulled his tongue out of my mouth and stood up from my bed. He stroked my face and told me how pretty I was. He told me that it was our little secret and no one could know, not even my roommate, with whom I shared just about everything.

I said, "Okay, I won't tell anyone." I watched him walk out of my room, ducking underneath the door so he would not hit his head. I just sat on my bed for a few more minutes, not knowing how to feel or what to feel about what took place. I just sat there wondering if it would happen again.

What seemed at first to be an innocent gesture of comfort would become something excitingly tainted. The kiss Jasen and I shared during those moments of consolation spurred other displays of affection. I don't really believe that I ever wanted those episodes to go on for as long as they did.

I felt morally conflicted. Jasen had two small children, a girl and a boy. He was married and his wife worked at the same place as my grandmother. I had never seen his wife, but I had seen his children before.

I knew what we were doing was wrong and it felt wrong at times; but instead of stopping the deceitful acts, I allowed it to continue. When we were alone, it was always behind doors that could be locked, like my bedroom, the visitation area and the staff's office. That way our torrid behavior could not be witnessed by anyone.

Neither of us discussed the consequences of being discovered. Through all that we did, I never felt any pleasurable feelings. He would lick inside of me and I just stared blankly at the ceiling, never looking at him. When he did that to me it made me uneasy. I wondered why he would want to put his tongue in the place where I urinated. I just hoped that he never asked me to lick him where he urinated.

I was awakened one night by kisses on my forehead. I opened my eyes to see Jasen standing over me. The moonlight cracked through the curtains of the window closest to my bed and reflected off his steel-framed glasses. My roommate had gone to her family's for the weekend. I was in the room alone. Jasen had worked the afternoon shift that day. Apparently he had stayed for the midnight shift as well. He worked alone that night.

Jasen bent down to kiss me on the lips. His breath smelled like peppermints. As he pressed his lips against mine, I pressed back. We kissed like that a few more times before he pushed his tongue through my lips. By then, I knew how to French kiss him. It no longer felt like his tongue chased mine. It was more like the two became one.

Jasen rose up to stand over me. He stared into my eyes with a half smile. He took his glasses off and set them on the desk next to my bed. He then unbuttoned the last two buttons on his mint green Polo shirt, pulled it over his head and tossed it on the floor. He pulled his white tee shirt over his head and also tossed it on the floor. That was the first time I had seen his bare chest, which was the color of caramel. I was used to seeing only the chests of the boys in the group home. They were half the size of Jasen's.

His upper body was defined. I could tell where each section

began and ended. His chest was hard. As I stared, mesmerized by his chest, Jasen continued to take off the rest of his clothing. Everything but his underwear was off as he climbed in bed next to me.

"Mmm, you smell so good," he said.

"Wait, it has another button. It's right down there," I told him.

"How does that feel?"

"It tingles a little."

"Do you like that feeling?" he asked.

"Yes."

"You are so pretty."

"Thank you."

"You're my pretty girl, okay."

"Okay."

"Open your legs a little wider. What is that on your panties? What does that word say? Tuesday? Today is Saturday. Taneshia, you've had those on since Tuesday, you are nasty."

"I have not. Just because they say Tuesday doesn't mean you only wear them on Tuesday."

"I know, I'm just playing with you. You feel so warm. Raise up a little, I want to take this off. Open your legs." He removed my panties.

"I'm cold, Jasen."

"I'm going to warm you up real soon," he told me.

"Ouch! Ouch! It hurts," I said.

"Shh, shh, shh. Okay. Just relax for me. That's it. Ooh, that's it. I love you."

"You love me, for real?"

"Of course. You're my pretty girl."

As Jasen lay on top of me, his body was heavy, even though he was mindful not to lay on me with all of his weight. I could

feel his breath on my neck as he moved me slowly up and down. It was painful to feel him thrust inside me. He kept trying for a while and then he stopped.

I was glad it was over. I pulled the covers up to my neck and looked away at the crack of moonlight through the curtains. I could feel Jasen's thumb and forefinger on the temples of my head as he turned my face toward him. He kissed me on the nose and then on the cheek. He walked out of my room just as quietly as he entered. Once my door shut behind him, I got up from my bed, found my underwear and put it back on. I didn't put the same nightgown on. Instead, I found some heavier pajamas. I thought I was cold, but I realized that I was just shaking.

The next morning, I got up early to take a shower and put on my clothes. Today was my home visit day with my grandmother. I usually got to spend the entire weekends with her but this visit was limited to just a few hours.

Jasen was gone when I got up for the day. I think I wanted to see him, but I felt strange about it. Last night was the first time we had gone as far as we did. We had done things like kiss, hug and touch one another. We had never had all of our clothes off before with all of our body parts touching.

I was sore between my legs. I kept making myself walk straight. I did not want anyone to see me walking strangely, especially not my grandmother. I got into the warm, streaming shower and washed myself, paying close attention to the area between my legs. I scrubbed hard, as if I wanted no evidence of Jasen's scent. The smell of his cologne still lingered on my body. It was like it seeped into my pores. I hoped no one would smell him on me. I just kept thinking, "Why did this have to happen today of all days?"

I got to my grandmother's house and one of my older uncles

was there. It was dark and quiet inside the house. My uncle stayed to himself, mostly, down in the basement. He only lived with my grandmother intermittently—once was after a prison term and other times were when he wanted to stay clean for a while. I had often heard certain family members refer to him as a genius. Now this genius of a man was enslaved by drugs and alcohol. Although he was that way, I was never afraid to be alone with him. I knew he wouldn't hurt me. He was only into hurting himself.

The silence of the house kept my mind wandering, remembering the events of the night before. My relationship with Jasen had changed. It was no longer just touching, but something more. I wondered if he would be coming to me for sex all the time. Sex with Jasen had hurt so much, I didn't think I was ready to experience it again. And then there was a smell coming from inside me. I had never smelled like this before. I was embarrassed. I went to the bathroom and washed several times but it only alleviated the smell slightly. What if my grandmother smelled it? What would she think of me?

I stayed at my grandmother's house for a few hours, but she never arrived. I wondered if she had forgotten about my visit today. It was just as well. I did not want her to think that I was unclean. Soon the group home van was outside sounding the horn. It was time for me to go.

When I arrived back at the group home, Jasen was there. He was acting silly, as usual. He was putting on a comedic performance in the foyer at one of the boy's expense. When he saw me he smiled slightly. I just proceeded past the crowd and up the stairs to my bedroom. My roommate was already there. She was excited to tell me about her weekend home visit. We always shared stories. I sat on my bed across from her and listened. I

knew I could not tell her about me and Jasen.

The things we did would stay between us for several reasons. I did not want him to get into trouble. I did not want to be teased by the other residents, especially the boys. I felt ashamed. I just sat and listened to my roommate's story.

Jasen knocked on the door. It was slightly open. He told my roommate that she had a phone call downstairs. She took flight off her bed and out of the room when she heard the news. Jasen came into the room and shut the door behind him. He asked how I was feeling. I told him okay. He told me how much he loved me and how important it was for us to keep our secrets between us. I understood him.

We walked out of the room together and to the top of the staircase to join the others on the first level. Jasen turned to me and hugged me, lifting me off my feet. He tilted his head and leaned in to kiss me. I followed his lead. The swinging door at the opposite end of the hallway startled us. We stopped and quickly pulled away. We both looked at the door, but there were no signs of the person who opened it. That door divided the girls' section from the boys' section in the group home. We were never allowed on the other side without staff supervision. I knew it had to be one of the boys. A staff member would have surely said something.

Jasen went through the door to see who witnessed our secret act of affection. He was unable to see anyone. My chest was pounding because my heart was beating so fast. We had always been very careful but now we had been exposed. All sorts of thoughts ran through my mind. Who was it that saw us? Would he keep it to himself or will he tell someone what he saw? It wasn't long before Don, one of the male residents, confronted me.

"You know that's wrong, Taneshia."

"What are you talking about?"

"You know what I'm talking about. Don't act stupid."

"Quit messing with me! Leave me alone."

"Jasen is not supposed to be messing around with you. He's taking advantage of you. That's a grown ass man! You are a little girl."

"I ain't no little girl!"

"You ain't no woman! That bastard is taking advantage of you! You can deny it if you want to but I'm telling. I'm telling you, that shit is wrong!"

After my conversation with Don, I knew that it would be a matter of time before every one else in the house would know of my elicit affair. I still denied Don's accusations in order to protect my image. Inside, I was truly embarrassed and I didn't want Jasen to lose his job.

Two days later, I was called into the Director's office at the group home. When I walked in, the director was there with Mrs. Redic, one of the female staff workers. The director sat upright in his chair and Mrs. Redic sat on a desk right by the door entrance. I knew what this conversation would be about. I was not looking forward to it.

Mrs. Redic conducted the inquisition. I denied everything. Mrs. Redic told me that it was wrong for a staff member to have that kind of relationship with a resident. She told me that I had done nothing wrong and Jasen was to blame. Not only was it against group home policy, it was also against the law for an adult to have an intimate relationship with a minor.

I stuck with my original answers. They dismissed me from the office. About thirty minutes later, I was whisked off to the doctor. I had to undress and the doctor examined my vaginal area. It had not dawned on me that I was at a special doctor's

visit. I thought it had been pre-planned. Mrs. Redic returned to the office to pick me up. She walked off with the doctor and held a discussion away from me. She was not very talkative on the ride back to the group home.

That afternoon Jasen was scheduled to work the afternoon shift. He never showed. When I did not see him again for several days, I knew Jasen had been fired. I cried when my suspicion was confirmed. I didn't let anyone hear me cry or see me upset. I was saddened that Jasen was no longer around. For a brief moment I did feel loved. I thought for sure that Don would spread my business around the group home. He didn't. He earned my respect for that. We never discussed what happened between Jasen and I again.

I was anxious for summer break to end and could not wait to start my freshman year of high school. Being in high school was a sign of my independence drawing near. I was no longer too young to hang around the older kids in the home. I went to the same high school as my roommate and some of the other residents. We would all finally have more things in common, more teenage things to discuss.

As the weeks passed, I hardly thought about Jasen. My relationship with him was slowly dissolving into a distant memory. I was in high school and it was swelled with cute boys my own age.

One day after school my roommate and I walked to a department store. We went to get some supplies—notebooks and binders for school. The supplies they issued at the group home were plain and generic looking. They did nothing for those of us who were trying to keep a "cool" image.

"Jasen!" My roommate yelled.

I turned around to see if it was really him and it was. My

heart started to pound as if it would jump out of my shirt. I almost struggled to get enough oxygen into my lungs because I was so excited to see him. I guess I missed him more than I wanted to admit. My roommate ran over to him. I walked slowly. He was standing in the aisle flashing his wide and beautiful smile. As I got closer to him, a tingling feeling came over me. My roommate hugged him and I patiently waited. I knew our embrace would be tighter and more meaningful, for we loved each other. I must have been showing all the teeth I had in my mouth because my cheeks felt as if they were tightening up. I stepped into him looking into his brown eyes. I opened my arms to receive him. He bent down slightly but seemed reserved. He did not lean into my embrace. I couldn't believe he had just given me a "half hug" with one arm around my shoulder and a pat on the back.

Jasen seemed distant. He asked us both how we were and how school was going. My roommate stayed with us for a few minutes and shortly walked away. With her absence, Jasen and I would have a chance to exchange more than casual conversation. I told Jasen that I was sorry that he had gotten fired and that I didn't say anything to anyone.

Jasen replied, "I'm a deacon for a church now."

I was thinking, what is he talking about? Was he trying to ignore what we had? Was he ignoring my feelings? I don't get an "I love you" or "I miss you"? Why would I care about him being a Deacon for a church. I didn't even know what a Deacon was. Did he expect me to just forget about everything as if nothing took place between us? All of a sudden, because he was God fearing and involved in church, he had the right to ignore me? I was furious.

I had cherished what we had. I stood up for him; for us. I didn't admit anything, trying to protect him. How stupid had I

been? He used me and tossed my feelings aside as if I did not matter. I felt even worse because I knew he was married and had met his children. That was how he repaid me for keeping our little secret?

Feeling Like
a Regular Teenager

Jasen had moved on and it was time for me to truly do the same. My social worker thought I would function better in another foster home, so I packed my bags once again. I arrived at Ms. Early's house with the same gray clouds in my heart that lingered in the skies. It was not quite winter but still very cold.

Once again I had to leave the people I had grown to love as my family. I was tired of moving, acclimating to new environments, meeting new people, getting to know them, starting to like them and then moving again. I was just fine living in the group home. Those kids were all the family I needed.

This move felt definite and final. I would be disconnected from the group home permanently. The only comfort I had came from knowing that I could at least continue going to the same high school. After all the new schools I had been in, there was a chance for me to keep the friends I had made even with my latest transition.

Another girl arrived at Ms. Early's on the same day. Her name was Netti and she was colossal. She did not look like she was just 16 years old. Her torso was long and wide like one of the linebacker's on our high school football team. Her head did not fit her body. It was small and round like a 12-year-old child's. Even her teeth were small, almost like baby teeth. Her head reminded

me of the stories I heard of voodoo priests who could shrink people's heads. Her hair was so short that she could not style it. It just stood atop her head most of the time. Her presence was intimidating. I was going to try my best not to annoy her. One thing I learned by growing up in a home of boys was never to let anyone sense that you feared them. I wasn't going to let her sense my fear.

Netti didn't pose any real harm. She was like a gentle giant. Her personality was silly and very child like. She was older, but I was more mature. Netti was almost 17 but had been left back several times in school. Although I had never seen her before, Netti and I attended the same high school before arriving at Ms. Early's house.

My school was divided into sections. There were "regular," "special ed" and "M.S.A.T." (math, science and applied technology) sections. The regular section was where most of the neighborhood kids attended. Special ed was the section for the academically, emotionally, mentally and/or physically impaired students.

I was in M.S.A.T. I really pulled one over on the school officials because with all my emotional dysfunction, I should have been in special ed with the rest of the emotionally impaired students. I was a master at hiding my emotions.

The M.S.A.T. curriculum was based on preparing students for higher education. We had more homework, special teachers and classes that were not offered to any of the other students.

Most of the students in M.S.A.T. did not live in the neighborhood of the school. We were from all over the city of Detroit. Some of the students came from well-to-do families equipped with privileged lifestyles and the attitudes to match, but most of the M.S.A.T. students were not snobs. Like programs at most

schools, M.S.A.T. was divided into cliques. Money hung with money. These were the kids who lived in places like Palmer Woods, an exclusive neighborhood in the city of Detroit. Sometimes the group home staff would take us on driving tours through that neighborhood so we could see the big beautiful houses. They resembled castles made out of stone and brick.

If you stayed in Palmer Woods, it was assumed that you had money and everyone around you had money. At school the money clique repeated outfits only two or three times a year. I had about five good outfits for the entire year. I mixed and matched and matched and mixed. I could not keep up with the money clique nor did I try. But I had to admit that a part of me envied them and longed to acquire enough wealth so that I would not have to want for anything.

For the moment, I had to be content with my three friends. We did not judge each other, but I still did not feel comfortable letting them know that I was a foster kid. I tried to keep a normal identity. My friends were cool and we had an understanding. They did not ask for too much information and I did not volunteer any. Some kids felt that they had to be up in other folks' business, but not my friends. For that reason, I was satisfied not to be in any other cliques. Others were nosey and had major attitudes.

Attitudes were definitely contagious amongst the students in M.S.A.T. It wasn't that we all thought we were better than the other students but we were recognized as being different. Teachers and faculty treated us differently. We were called nerds. Some regular students would joke that they could not venture to the M.S.A.T. side of the building because their brains might explode. There were plenty of jokes about us, but it did not keep some of the finest and most popular boys in the school away from the girls in M.S.A.T. Nerd or not, if you were cute, you got

attention. In high school hormones conquered all. When you were cute and smart, people paid attention.

For me that was a good thing and a bad thing. I never wanted to draw too much attention to myself so I could maintain some sense of normalcy. For the most part, it worked, but then I had a run-in with Netti.

"Hey sister! Sister!"

"Damn," I thought.

"Who is that, Taneshia?" my friend asked.

"Umm, nobody."

"Is she talking to you?"

"What? Naw, she ain't talking to me. You know it's at least 50 girls named Taneshia in this school. C'mon lets go so we won't be late." I avoided a potential situation.

I did not have a choice other than to ignore Netti. What was she thinking by calling me out like that? She just made a spectacle of herself but was not going to make one of me. Besides, why was she calling me sister anyway? I wasn't her sister.

As soon as you moved in someone's household, they were always eager to put claims and titles on you. I was always someone's daughter, sister or cousin. I was not related to any of them, nor did I want to be.

"Did you hear me calling you today?" Netti asked when we got home.

"Look, Netti, you can't be yelling at me in the hallways like that. You might have gotten us in trouble."

"No one was around."

"It doesn't matter. We were right near the office. Just don't call me out like that again, okay?"

"Okay." Netti sounded very hurt by our conversation.

I guess denying her was my way of letting her know not to try to get close to me. We did not look anything alike anyway. I would have a tough time trying to explain her to anyone at school. If any of the students in M.S.A.T. found out that Netti and I lived in the same house, there would be too many questions. I was not ready to answer any questions or let anyone know my secrets. After all, she was just one of the four other females I lived with under the same roof. I was not going to claim anyone in this new house. I didn't have any title problems like that at the group home. Getting close to anyone in the house was not part of my plan. My plan was just to make it out of the social service system and be rid of foster homes and social workers.

Ms. Early didn't go out of her way to make me feel comfortable living there. She never interacted with any of us new girls. She stayed in her bedroom just lying on her bed with the television on. She always seemed to have on the same floral print dress. It must have been her favorite. She wore a kinky bouffant wig. She was a large woman with an attractive face.

I often wondered what she did all day besides lie around and watch television. She did cook sometimes, but there was not a lot of variety to the meals she prepared. Usually there was some kind of meat with a tossed salad. Most of the food was quick and easy to prepare, like boxed macaroni and cheese. In most black family households boxed macaroni and cheese was the lazy person's way to make that traditionally homemade dish. My previous foster mother told me that. She showed me how to prepare what she called real macaroni and cheese with eggs, butter, milk, a little sugar and the very important "gov'ment" cheese. Boxed macaroni and cheese paled in comparison. The real stuff took time and preparation. The only thing Ms. Early took time to prepare was a chore list.

She knew how to give orders. We kept the house clean and

tidy. Her daughter had chores, too, but we cleaned up after her because she always did a less adequate job. She was young and spoiled. There was a four year age difference between the two of us. She always wanted to hang with the older girls, but we didn't let her because it was too much of a hassle. She would tell on us when we did anything that resembled defiance against her mother or the house rules.

She was a liar, also. The other foster girls and I could not stand her. We mutually called her "the brat." Netti and the brat often disagreed. She had to be really bad for Netti not to like her because Netti was the most welcoming of all the girls.

I remember the time when Ms. Early went out of town and she hired her friend's mother to stay at the house with us. The sitter was a passive woman and it was almost like we were there alone. She did not yell or scold and she always went to sleep early each night. We basically had free reign of the house. I would stay on the phone as long as I wanted with my boyfriend. Coincidently he was the sitter's grandson. He was just a year older than me. We seemed to like each other as soon as we met. He was cute and he had braces on his teeth, just like me. Sometimes we talked on the phone for hours. I got teased about it often.

The sitter had taken all of us to her house for a day. I was excited because I would get the chance to see my boyfriend. We were still on kissing status. The girls often joked about our braces getting locked together. We were careful. When we got to the sitter's house, my boyfriend and I went down to the basement where his bedroom was. We weren't alone for too long because Netti found her way downstairs and soon after, the brat was there also. Just 20 minutes had passed and they began arguing about which television program to watch and possession of the remote control.

I tried to ignore them at first as my boyfriend attempted to keep me engaged in our kissing marathon. They started getting louder and louder. I tried to quiet them because I knew if the sitter heard them, it would be the end of our visit. It was challenging for them to keep quiet and we left the sitter's house a lot earlier than I had hoped.

Later that evening at Ms. Early's house, the sitter went to bed and the fireworks began. The tension that had been erupting between the brat and Netti was ready to explode. I didn't know what that little girl was thinking by going up against Netti. The brat was not a petite girl, but Netti still towered over her by at least seven inches. I was in my usual spot on the telephone and I heard the brat yell, "Bitch, you ain't gone do shit to me!"

"Here we go," I thought.

I went into the kitchen to see what was going on. Netti was two seconds from stomping that little girl. I stood in front of Netti, but she was blowing past me like a freight train. She was ready to give the brat a thorough beating. It took all of us to restrain Netti. We didn't hold her back because we were protecting the brat; we held her back because we were looking out for her best interest. We all knew that if Netti laid one finger on Ms. Early's daughter, she would be removed from the house. None of the foster girls wanted to see that happen. There was something about being foster kids that was bonding. We had an "us vs. them" mentality. It was like the foster kids' code of ethics—a non-verbalized agreement. We didn't tell on each other.

It was very tempting to let Netti get in a few good hits but ultimately, I knew it wouldn't be wise. As we formed a barrier around Netti, the brat must have felt a sense of security. She tried to agitate Netti even more. The scene was like a child teasing a chained dog behind a fence. The child knows that the dog can do no harm as long as it is restrained. I told the brat to be

quiet before I quieted her. She finally did. The chaos was over and everyone went their own way. The sitter never awoke from her sleep.

Two days later, Ms. Early returned from her trip. We all had managed to get along without any more uprisings. Everyone had been very pleasant to each other. We were even letting the brat hang out with us. The situation that occurred on the previous night was over, done with and in the past. There was no need to bring up the past. Right?

The brat was just waiting for her opportunity. She could not wait to get her mother alone so she could fill her in on all of the week's events. She told things about us all. She told her mother that I had been on the phone most of the time and she told her mother that I was locked with my boyfriend in his bedroom. She also told her mother that Netti tried to beat her up for no reason.

I had just fallen asleep when I heard Ms. Early come storming up the stairs. She went to Netti's room and flicked on the light. I opened my eyes and sat up in my bed to listen. Ms. Early was furious. She yelled at Netti. "How dare you think you can put your hands on my kid? You are three times her size! You better not think about touching her! As a matter of fact, if you say something to her out of the way, you will have me to deal with!"

Netti could not even get a word in. I wanted to say something, but I just sat there, frozen. From that point on, the relationship between Ms. Early and Netti was strained. I knew it would be a matter of time before Netti would have to leave the house. Netti must have felt as though she was walking on thin ice. That was the feeling most of us foster kids had. No one had to put up with us. We were expendable and we were treated as such. However, Ms. Early's boyfriend saw fit to treat us differently.

Jimmy was a humorous man. He laughed all the time and kept us laughing with him. His belly would shake just like an animated Santa Claus. He would make fun of all of us. No one was off limits; not even Ms. Early.

Ms. Early and Jimmy seemed to have very opposite personalities. He liked to do things and would include all of us in his plans. Ms. Early stayed in her room watching television on her bed most of the time.

He treated us like family; not like we were just some foster kids. We loved to see Jimmy come over and hated to see him go. The brat was not too happy about the time her mother spent with Jimmy. I think she was jealous. She was only happy to see him when he had a gift for her.

Jimmy took all of us to dinner one evening. Ms. Early announced that she and Jimmy were getting married. We would be moving into his house and I was glad for that. He had a nice house in an even nicer neighborhood. Jimmy was much more fun to be around.

The duration between the engagement announcement and the wedding was short. We were moving our things from one place to the other. We packed our belongings in Ms. Early's house and moved into Jimmy's house. By the day of the wedding, we were all moved in.

They held the ceremony at Jimmy's house. It was a small wedding—only their immediate family and friends attended. Jimmy had three adult children: a son and a set of twins—a male and a female. The twins and I shared the same birth date. The twins were about 10 years older than me and both had children of their own.

Jimmy was smiling and laughing the whole day. Ms. Early seemed happy but she didn't act like a bride-to-be on her wed-

ding day. She didn't appear to be doing much more than going through the motions.

Life with Jimmy and Ms. Early was much better than with Ms. Early alone. Jimmy really interacted with all us. He tried hard to bond with the brat. She often rolled her eyes and snapped at him. I thought she was jealous that she no longer had all of her mother's attention.

My approach to the new living situation was to make the most of being around Jimmy. He was a father figure to me. Jimmy treated me with kindness and respect as long as I did the same.

Once, Jimmy and I had a major disagreement about the telephone. As a teenaged girl, the telephone had me under a hypnotic spell. I always wanted to be on the telephone and got irate when I was told to that I could not use it. Jimmy demanded that I get off the phone one night and I refused. He tried to take the receiver out of my grasp. When he grabbed the phone, I threw it and hit him in the arm. What was I thinking?

When I realized what I had done, it was too late. Jimmy grabbed me by the collar of my shirt and yanked my not-so-small body out of the chair. He flung me on top of the kitchen counter top and pinned me between the microwave and the kitchen sink. I didn't cry or scream out, but I was terrified. I had never seen such anger in Jimmy before. Ms. Early ran into the kitchen commanding Jimmy to let me go. He held on tight. She positioned her body between me and Jimmy. She grabbed hold of his arms, pushing him away. That was the first time I had ever felt as if she cared anything about me. I eased myself off the counter top and ran up to my bedroom.

AWOL

Much like the group home staff that I saw come and go, the foster kids came and went. By the time I had spent one full year with Jimmy and Ms. Early, all of the other foster girls had gone and were replaced by boys. Boys brought an entirely different atmosphere to the household. They definitely smelled more and were never good at cleaning the bathroom. There was no way that I would consider them as my brothers. But there was one who I was particularly fond of.

He wasn't a foster child, but Jimmy's and Ms. Early's biological son, Lee. Ms. Early had him shortly after she and Jimmy were married. Finally, there was a reason why Ms. Early would lay around the house so much. I thought she was just lazy, but it turned out that she was pregnant.

Lee was a cutie. I fell in love with him instantly. The brat loved Lee, but I considered him my little brother, too. I wanted to claim him and wanted him to claim me.

I often thought about why I claimed Lee as my little brother but didn't claim anyone else as my relative. As a little kid, Lee didn't know the difference between being bound by blood or situation. He loved me like he loved everyone. I felt close to Lee just like I felt close to Jimmy. Even the brat and I became friendlier with each other.

Ms. Early and I continued our strained relationship. She

would refer to me as her daughter, but there were always distinct differences in the way the brat and I were treated. We were never on an equal level when it came to birthdays, holidays or gifts. It didn't bother me that she got more because I knew my place. I was one of the foster kids and I understood that.

Foster kids not only lived by the rules of the house but also by the rules of the Department of Social Services. We didn't go clothes shopping when we wanted to, but when the social worker provided the stipend. We could not go out of town or spend the night at friends' houses unless it was authorized by the social worker. I gave credit to Jimmy and Ms. Early because they did allow me some privileges without going through the social worker.

Sometimes I felt like I was living in a minimum-security prison. I thought I should have had more freedom. After all, I was 16 and only had one more year of high school. I could not wait until my eighteenth birthday. That would be the day I was released from the social service system. There would be no more rules or guidelines that I had to abide by. I could almost taste the freedom. It was waiting for me and I was anxious to have it.

I had a girlfriend from school whose lifestyle reminded me of my desire to be "freed." Her name was Alecia and I called her Lecia for short. She was living the life that I wanted with minimal rules and the ability to come and go whenever. It seemed as though she got away with murder. She was 16 like me, but was able to do so much. Her mother was not nearly as strict as Ms. Early was with me. Lecia was able to spend the weekends with her boyfriend in hotels. Her boyfriend was an adult, not a high school student. Lecia had her own car, wore very nice clothes and shopped a lot.

I envied her but she didn't know it. We often talked about what it would be like if I lived with her and her family. I imag-

ined how much better my life would have been. Her mom was cool. She was much more passive than Ms. Early.

My desire to live with Lecia and her family was reflected in my attitude at Ms. Early and Jimmy's house. Ms. Early and I would get into shouting matches and I would snap and roll my eyes at her. Living in the house was becoming unbearable and I was rebellious and unruly. I was tired of living there. I wanted to get out before I turned 18. I would miss Lee, Jimmy and even the brat, but I was ready to go.

Lecia and I started devising the plan—"Operation Free Taneshia!" I would run away from home and live with Lecia and her family. Every day I packed some of my clothes into garbage bags and stored them in my bedroom closet. I had my own room, so no one was aware of what I was doing.

The end of the school year was drawing near and I would make my move after the semester ended. We had it all figured out. At night I would hide my clothes in the bushes in front of the house while everyone was upstairs in their bedrooms. My cousin, who was a senior in high school, would pick up my clothes from the bushes and keep them in the trunk of her car. She had a big car with a big trunk that could hold all of the bags. With my clothes in a place where I could retrieve them, the only thing I'd have left to do was to leave.

I was scheduled to take my ACT College Proficiency Examination on the Saturday after the school semester ended. I had planned to leave Jimmy's and Ms. Early's house that day to take the ACT test and never return. Lecia and I had worked weeks on the plan. The plan appeared to be going along perfectly until Ms. Early started snooping around.

Panic started to settle inside me as I feared that she knew what I was up to. She seemed to start watching me more. In my mind, she had been playing "super sleuth" in my room. I

thought she had searched my closet and seen the bags of clothing. Sometimes I thought of just telling her that I was leaving. It seemed as though she hated me anyway. Why should she care if I was there or not? We weren't getting along. She never showed me any affection. I was tired of being in a place where I felt unwanted.

I felt it was imperative to speed up my plans. I wanted to get my stuff out of the house and into my cousin's car so there would be one less thing to do. It was difficult because I was never in the house alone. Earlier in the week, I had started to put the garbage bags of clothes in the closet near the front door. There were already other garbage bags in the closet that were filled with Jimmy's old clothes. Jimmy's bags would be a good diversion because my bags would not be suspicious.

The day came to put the plan in motion. I called my cousin to see if she would be able to drive over that night to get the bags. When night came, I waited until everyone was upstairs. Jimmy and Ms. Early's bedroom faced the back of the house so I knew they could not hear me. I started taking the bags out of the closet, quietly. I opened the front door and put each bag underneath the big hedge in front of the porch. At night the dark hedges and the bags blended together and everything looked black. I was really hoping my cousin would be able to see the bags. I went back into the house. As I closed the front door, careful not to make any sounds, Ms. Early yelled my name from their bedroom. I ran to the top of the stairs to see what she wanted.

"What are you doing?" she asked.

"Nothing," I replied.

"It didn't sound like nothing."

"I wasn't doing anything," I insisted. I walked up the rest of the stairs and proceeded to my bedroom.

About 30 minutes later, Ms. Early opened the door to my room. "Come down here and get these bags from outside," she snapped.

"Damn," I thought. How could she have known? I walked down the stairs. The darkness of the house was broken only by the glare of a red light in the dining room, which was next to the front door. I turned on the dining room light to see where the light was coming from. There was a baby monitor on top of the china cabinet. "When did she put that there?" I wondered. She must have put it there sometime that week. It must have allowed her to hear the slight rustle of the bags and the opening and closing of the door.

As I brought the bags inside, I felt disgusted. I didn't know how I was going to get out of that situation. Ms. Early came downstairs and asked me if I was planning to run away. I just looked at her as if her mouth was moving but no sound was coming out. I didn't answer her. Her voice got higher and cracked a little as she kept repeating the question. I just gazed off looking at the wall beside her, stupefied. I did not feel like talking.

The plan I had worked on for weeks was starting to crumble. I wanted to call my cousin to warn her not to come over, but of course, I wasn't allowed to use the phone. There was nothing left for me to do except go to sleep. I had made up my mind to try to come up with a new plan on the following day.

Morning came and no one was home except for me and Ms. Early. She busted into the room, forcing the door open so fast that it hit the wall. She turned on the light and said, "You can get up and get your stuff ready. Mrs. Larkins is coming to get you."

Mrs. Larkins was my social worker and I could not stand her. She was a tall, scary looking woman. She had a very dark complexion with long, silver hair. Her teeth were yellowing and a few were pointy like fangs. She had very long nails that curled

over her fingertips. Mrs. Larkins reminded me of a vampire from the movies.

You could tell that she was one of those people who did not like her job. She never seemed to take any real interest in me. When Ms. Early told me that Mrs. Larkins was coming to get me, I knew that meant one thing. I was going to a "lock up," also known as juvi. A lock up was a maximum-security facility. Since I was attempting to run away, I knew for certain that was where I was headed.

I had to change my plan. I was forced to move hastily to avoid my fate. I stuffed some clothing and underwear into a small duffle bag. I tried to gather everything I deemed valuable including my Gucci bag from Italy that my mother had given me, a few pieces of gold jewelry and some cassette tapes of my favorite music. My possessions of the world were few and weren't worth much to anyone but me.

When I was done rummaging through my things, I strapped two duffle bags across my body and put my Gucci bag and a small knapsack on my shoulder. I hurried out of my room and ran down the stairs as if someone was chasing me. I went out the front door and started walking down the long street. I was heading for the bus stop. I walked as fast as I could, almost jogging. All of the things I was carrying flapped against my body.

My heart said that Ms. Early was not going to attempt to stop me or come after me. She wanted me gone anyway. I just wanted to get to the bus stop before Mrs. Larkins got there. She would have tried to force me to go with her. Mrs. Larkins seemed like the type of person to put her hands on a kid, regardless of her job regulations. The fact that I made it to the bus stop was proof that my expectations of Ms. Early were right. She didn't care.

About 10 minutes passed and the Grand River bus finally

came. Adrenaline was pumping through my body. I calmed down once I took a seat and rested my things. Everything happened so fast, I could not think of where to go. I thought that I'd at least ride the same bus route that I took to school. That meant that I'd have a 40-minute ride to downtown Detroit.

The last stop of the bus route was coming up. I gathered my bags and walked off the bus onto Woodward Avenue. It was morning, and Woodward was busy as usual with people everywhere. There were businesspeople, police officers, shopkeepers, patrons and the homeless. I was like them—the homeless. I had no place to call home or any place to go where people felt responsible for me. All sorts of thoughts and feelings rushed into my head. Would I become like the homeless people I saw on Woodward Avenue who begged for spare change or a meal? Would I have to sleep in an alley? Where will I go when it rained? What if some of the kids from school saw me? Why couldn't I be like ordinary kids I knew who had families to call on? Why, after all of those years, hadn't my mother ever tried to get me back and where was she now?

I had to think of somewhere to go. The morning had turned into the afternoon and soon it would be evening. I didn't want to be on Woodward when night fell. I found some coins in my pocket and went to the payphone to start dialing numbers.

No Place to Go

Over the next three months, I wore out my welcome at all of my friends' houses. Ms. Early had the names and numbers of all my friends, so staying with them was always risky. Most of their parents were hesitant to let me spend one night with them. I never wanted to get any of my friends or their parents in trouble. Sometimes I stayed with people I did not know to keep from having to sleep in an alley. All of the clothes I took with me had dwindled down to a change of clothes and a few pairs of underwear.

I always had to be ready to move. Any money I had stayed on me or within my sight at all times. My jewelry was stolen at one house by someone I barely knew. I felt alone and loveless most of the time. Living felt difficult and meaningless. "Why was God punishing me?" was the question that often came to my mind. My entire life I experienced more pain and sadness than joy. I wanted to know why I had such a hard and unpleasant life. I did what I was told most of the time, but it still wasn't enough. I did not want to continue living and feeling that way. I often thought about ending my life, but the thoughts of how and where never conceptualized. I was feeling as if I reached the end of my rope. I did not have the desire to go any farther.

I called my cousin because I needed to talk to someone. She had always served as a source of comfort for me. Before I could

say anything, she told me that she had been trying to reach me for days. She told me that our cousin, Manny, who was an adult, was offering his house as my place of refuge.

It had been about seven years since I had seen him last. That didn't matter. I was so grateful for his offer. When I got to Manny's house, he said something to me that made tears pour out of my eyes. He said, "You don't have to run anymore. I'll take care of you."

Manny became my legal guardian. Mrs. Larkins made arrangements for him to get financial assistance by enrolling me in to an independent living program through another agency. Independent living meant that I was of age to live as a semi-independent with adult supervision. I was able to stay in the program as long as I abided by the guidelines.

Mrs. Larkins wasn't so bad after all. She visited me one last time at Manny's house and brought the clothes I left at Ms. Early's house. It was the first time I had seen Ms. Larkins since I ran away. When she got out of the car, even Manny thought she looked scary. When I retrieved all my things from her car, I knew that was the last time I'd have to see her. She called me her "pet peeve." I didn't know what that meant, but it didn't sound good.

That Fall, I started the school semester a little late. I transferred to a high school that was closer to Manny's house. I missed my old school and my friends, but I was happy that I was finally living in a stable place. The school year went by quickly. I only had three classes each semester and I did not socialize with many of the seniors who would be graduating with me. Of the few students I did talk to, some of them envied me because I lived with my cousin. He was not perceived as being strict. Imagine that. Some people actually wanted my life. How crazy were they? How cool was that?

Manny was in his twenties, so he still related to his youth and decided to treat me as an adult. I appreciated him so much that I really tried not to take advantage of him. For one thing, I never skipped any classes … after all, I only had three. When he and his roommate were at work, I didn't turn our house into a hang-out spot.

There was a stipulation to my light class load, though. I had to work a part time job for at least 20 hours a week. I worked at a franchise sandwich shop. That job was too much for one person to handle. I felt like I was working as a plantation slave. The owner did not know anything about running a franchise and I probably only saw him on two occasions while I was employed there. He put most of his trust in the general manager, Tara, who was very dishonest. She would schedule me to work alone but would tell me that someone would work the shift with me. I had to prep the food, serve the customers, clean up and close down. There were many school nights that I didn't leave before midnight. It was scary being there alone at night. I often thought that if someone ever robbed the place, I would not put up a fight. I would give them access to the cash register and show them where the safe was. No job was worth putting my life in jeopardy, especially not for five dollars and twenty-five cents an hour.

I asked for raises and Tara always promised but never delivered. I was not getting paid like a manager even though I was working like one. I needed the job for school credit and for spending money to get my hair done regularly and to buy clothes, like most teenage girls.

As graduation drew near, my hours and responsibilities increased. The job was beginning to be too much and I wanted to quit. As soon as the opportunity arose, I did. I had managed to save a small amount of cash to use for a couple months and

to buy my graduation dress. My expenses were low and as my guardian, Manny was still getting money to help out with the household items.

Three weeks before graduation, the seniors were getting ready for the senior trip, prom and the Cedar Point amusement park outing which was always on the day after prom. I had been asked by several guys to be their date, but turned them all down. I couldn't afford to go to anything. My cousin didn't go to his prom when he was in high school so it was not a big deal to him. I didn't even ask him to help me out. I thought he had done more than enough by allowing me to live with him. I wanted to go, but I had to be mindful of how I used my money. I had just enough money to get my hair done and buy a dress and shoes for graduation day.

I was excited about graduation because it would be the true start of my independence. Soon after graduation I would turn 18 and would no longer be a ward of Wayne County. There would be no more social workers and no more prohibitions.

Independence Realized

Graduation was an exciting time for me because I would get to see my mother. It had been nearly three years since I had last seen her. I was anxiously awaiting her visit. I missed her. No matter the condition of my life, I still adored my mother and cared what she thought of me. She was living in Texas with a man who was in the Army. I had spoken to my mother several times that year. Every time we talked, she spoke of how well she was doing. That's how my mother was. She was always claiming to be living the life of a celebrity.

She had driven for two days from Texas to Michigan by herself in her boyfriend's sports car. I was so happy to see her. She was wearing her hair short and cropped and had gotten about two shades darker. She still looked beautiful. I always thought my mother was a pretty woman. With her new look and nice car, she did seem as though she was doing better than fair.

There were only a few days until the graduation and my mother had stepped into the mix as if she had always been there. She was making arrangements and taking me around to all of her old friends announcing how proud she was of me. She angled the situation in her favor so her friends would now know that I hadn't lived with her for all of those years. She was the queen of manipulation. I wanted to give graduation tickets to Ms. Early and Jimmy, but my mother had other plans for their tickets. She

wanted them to go to two of her old friends. The tickets ultimately went unused.

My mother said that she would take me shopping for my graduation dress. I was really under the impression that she was going to pay for it. When we got to the cashier to purchase the dress, my mother looked in her purse and looked at me and said, "I must have left my money back at the house. You'll have to pay for it and I'll give the money back to you."

I never got the money, but she told everyone that she bought the dress. My mother started saying it so much that she really believed it and would say it around me. I did not feel the need to correct her. After all, I knew who she was and what she was about. She was only interested in making herself look good, even if she had to be dishonest. After all of that time, she still did not have my best interest. It became apparent to me that I was the only one who had an interest in my life.

After the graduation ceremony, there were no questions about my plans for the future, but I did not have any plans. I wanted to attend a university, but financially, it seemed impossible. College was just a wish—a figment of my imagination. Unfortunately, I was not living in a fantasy world. My world was the cold, harsh reality that warranted minimum waged jobs for high school graduates. After turning 18, I was released from the confines of the social service system. With that freedom came financial responsibility. My cousin was no longer receiving assistance for me, so I had to begin pulling my share of the load.

On the Way to Better Days

A few days after walking across the stage and receiving my high school diploma, I was walking down the suburban streets of Detroit looking for employment. With copies of my resume in hand, I applied for jobs everywhere, from nursing homes to grocery stores, trying to market my limited skills. By the time I made it home, the grocery store manager had left a message for me to come in to interview as a cashier. It didn't pay much, but it was money.

Money was always an issue and I wasn't getting enough hours as a cashier to pay all of my bills and to keep a savings account. I found additional employment through a temporary placement agency as a file clerk. Between the two jobs, I worked from 7:30 a.m. to nearly midnight. I was miserable. I could not fathom the idea of working like that until the age of retirement, considering that I was only 18. I desired more for my life and I owed it to myself to find out what "more" entailed. I believed that if I were going to make more money, I needed more education.

I wanted to be more than my parents. My mother got her GED and I think my father dropped out of high school. As a child I always thought one of the major sources of my mother's anger and physical abusiveness was due to financial stress. In my heart, I knew I was a different person than my mother, but

I didn't want to risk growing up to be abusive to my own children because of financial stress.

I began a quest to find a way to go to college. I always thought that college was for the kids who seemed to lead normal and average lives; those kids who had parents or families who supported them. I never thought that I could afford to be there, but I had the desire to have a life of privilege. In my mind, my experiences growing up were the lowest point of my life. I believed from the depths of my soul that there was no where for me to go but up.

I went back to my alma mater and sought the assistance of the senior guidance counselor. We looked at my school records and found that I was eligible for several scholarships. I filled out financial aid forms for government assistance and applied to several universities. I was considered an independent student because I could file for financial aid as a former court ward. That allowed me the government assistance I needed.

It made more economical sense for me to stay in Michigan but I didn't want to stay in Detroit. I would have access to too many potential distractions in the city—men, nightclubs and the temptation of keeping up with fashion trends. I had to go away and be totally focused.

After months, I'd set a plan. The September following my nineteenth birthday, I would be an enrollee at Ferris State University. The university was in a small town about 200 miles from Detroit. It was far enough to stay focused, but close enough to get home when I needed to. The town was so small that it probably took 10 minutes to travel the entire vicinity.

I often saw people riding in horse drawn buggies. Before Ferris State, I thought that lifestyle only existed in movies about the Old West. But these people were Amish and they did not

live amongst the townspeople, but in a community of their own. Seeing them amazed me.

The first few days at the university felt almost like a fairy tale. The air felt crisp and smelled fresh. I was just entering the new world that would be mine for the next few years. The excitement of it all was overwhelming. I did not care that the town and school was predominantly populated with people who did not look like me. I was happy to be in school and was ready to embrace every opportunity that awaited me.

After all the years of concealing my identity to school friends, transitioning between group homes and foster homes, and feeling as if I would never do or have anything worth recognizing, I had finally arrived. For the first time in my life, I was just like most of my peers. No one cared about my history, my previous living situations or my wardrobe. I was just a struggling student. Finally, I was ordinary.

The Road to Success

I was terrified during the beginning of my freshman year. Even though I had a roommate and was meeting people, I still felt as if I was going it alone. By that I mean that I did not have the family support (financial or emotional) that many of my peers had. However, I did think that was my chance to show all the people who doubted me or said I would be on welfare, that I would succeed. I had to prove it to all the friends and coworkers back home who said I would be back within a year. I had to prove that I could do it.

With my high school involvement in Distributive Education Clubs of America (DECA), I thought the logical choice for me at Ferris was to enroll in the school of business. The major I selected was nothing like I thought it would be. I started looking into other curriculums and decided that since most of my high school education was based around math and science, I would do well in medicine or engineering.

The dean in the school of technology told me about a new program called Plastics Engineering. He really thought I would like it. Since I didn't want to go too long without a major, I decided to go with it.

That curriculum turned out to be a challenge. I was intimidated more times than not by my own insecurities. About 97 percent of the students in plastics were white and had come

from the suburbs or small towns where there were no blacks. I felt like I had to prove my intelligence to my peers, teachers and myself. I did not think I was as smart as my classmates, and learning about plastics engineering did not come easily. I questioned whether I had picked the appropriate major right up to my graduation day. I stayed with plastics not because I liked it, but because I did not want to rack up a ton of student loans trying to seek out my true interests.

My peers in plastics helped break the racial stereotypes that had been embedded in my mind by some family members and friends. At times my white peers were quicker to help me than anyone else. Indirectly, they also pushed me to keep going. I wasn't a very competitive student. I didn't have the highest grade on every test, but I sure did not want to be one of the students who had the lowest. I felt like I was always proving my worth as a student from Detroit, as a black person and as a woman.

College provided a well-rounded experience. I learned that certain things, like keeping up with the latest trends in clothing, hair and cars, didn't hold as much value as I once thought. I was able to view things through the eyes of people from different cultures and statuses. I also learned that the most important thing I needed to do was to complete my degree. I was serious about finishing and I didn't allow myself to be swayed. Most of the people I hung around had similar attitudes.

The most important lessons were those of determination and tenacity. I learned to ask even with the risk of being rejected; to find ways to keep going no matter what. If money was an issue, I found a way around it by selling clothes to students and getting up at the crack of dawn to work the breakfast shift in the cafeteria, then going back to work the lunch shift. My cafeteria job served two purposes: It put money in my pocket and at least two meals in my stomach.

School was hard and a lack of financial assistance was a contributing factor. My tuition was taken care of through scholarships and financial aid but living expenses, pocket money and book money were issues every year. In addition to my financial concerns, I knew that engineering was traditionally a man's job. I found myself having to constantly speak up to get my fair share of working on the equipment. I would often feel disengaged because I was worrying about money.

There were times I contemplated dropping out. Some of the people in my life encouraged me to do just that. I remember my mother trying to get me to join the Army since she lived near a base in Texas. But I had to stick with school because I did not want to let myself down. If I quit, I would have been doing just that.

Success

Moving From
Survival to Success

For years I felt like I was in survival mode. I was too busy dealing with current circumstances to even think about my future. I later realized that thinking about the future was necessary to establish a direction for my life. I observed and read about people who were successful. I also looked at the people who were not successful. Seeing people in both positions helped me determine how I wanted my life to be. In comparing the successful to the unsuccessful, I noticed that the successful people had structure and organization in their lives. I noticed that they viewed goals as projects to be completed. The most important thing I noticed was their drive and determination to ensure the completion of those projects.

I also learned that college did not serve a typical purpose for me. Yes, it was a ways to a means—a good job with good pay and benefits. However, in completing course requirements in a curriculum I didn't like, I discovered something about myself. I knew that I had stamina and drive to complete a project, and for me, obtaining my degree was a project.

I cannot discount what I learned in college because it opened my mind to not only institutionalized knowledge but also to knowledge of other cultures, people, and what would turn out to be my true passion in life.

Early in my college experience I knew I liked helping people feel better about themselves; doing that helped me not to be so hard on myself. There were some students I tutored in math and English literature. As the years went by, I became a mentor to incoming freshmen, motivating them to stay focused continue their education. I would tell them a little about how I grew up, and it encouraged them. It was therapeutic for me because it showed me that there was a reason why I went through the things in my past: to help people I would encounter in the future.

Striving for success gives me the constant ability to aid others in obtaining their own success. In order to reach certain levels of achievement, I've had to develop a structure for thinking and acting that does not hinder my progress. I share elements of that structure in these next chapters to help you reach the success you deserve.

Use Your Past to Shape Your Destiny

"That which we are, we are ...
and if we are ever to be any better,
now is the time to begin."
Alfred Lord Tennyson

Facing challenges and adversities is a part of life. All challenges and adversities help build character, strength and spiritual stamina. Experiences create life's lessons. With these lessons we must recognize, learn and grow. Someone I once knew made the analogy that people are like keys being formed. Just like keys are cut, shaped and formed, we are formed through our experiences. Just like keys unlock, we can unlock something within ourselves or within others.

Until I was able to understand that there were reasons for facing adversities, I thought I was being punished or permanently subjected to a life of unhappiness. When I developed that understanding, I realized that poverty and physical, emotional and sexual abuse could not doom me to a life of destitution and deprivation.

Those experiences are a part of my history but not a part of my future. I decided not to let my past interfere with my future. When I became responsible for my own actions, I was determined not to concede to a life of victimization and statistics.

After discovering my ability to acclimate, transitions became less weary. I adapted to every situation and every new environment. With a sponge-like mind, I absorbed as much knowledge, motivation and survival skills as I could.

At the age of 19, I was able to turn my life in a more positive direction, uncovering my dreams of a better existence. Encouraged to pursue higher education, I set my sights on higher education so that I could achieve a higher earning potential. Five years and thousands of dollars in student loans later, I received a degree in engineering. By allowing my past experiences to become resources for building endurance and character, I was able to attain goals that sometimes seemed beyond my capabilities.

I found that the key element in moving forward with my life and building a solid foundation was not to dwell on what happened in the past. Some of us can get caught up in spending too much time thinking about how bad things were, instead of thinking about how good things can be. Some nights I cried myself to sleep and became depressed with the thought that no one believed in me. Sometimes I felt sorry for myself and gave into the lure of self pity, but I recognized a need to change my energy and a need to love myself.

When we look outside ourselves for love and happiness before recognizing what we have within, the love we find will often be temporary. When we look outside for love before loving ourselves, we tell ourselves that love is out of our control. We waste our time and effort in searching for the love that has been within our reach all along.

Loving myself helped to build an unwavering confidence and respect. It was only when I discovered the love within that I was able to open my eyes to see that the external love I thought I was missing was always there in family and friends. When they

witnessed me being productive and pursuing my goals, their encouragement came in abundance. I would not have realized that support had I continued to let my past experiences keep me from having a positive future.

Do not dwell on what was, but focus on what is and what shall be. Accept and love yourself for who you are. Learn from your past experiences and use them to guide you to a brighter future. Always remember that through the trials come triumphs.

Decide To Be

"The vision that you glorify in your mind,
the ideal that you enthrone in your heart—
|this you will build your life by,
and this you will become."
James Lane Allen

After people learn of my past experiences and how I grew up, they often inquire about what helped me be the person I am. I simply tell them that I decided to be the person I was designed to be. For some that answer may pose slight confusion, so I offer additional explanation.

Much of the negative experiences I encountered were caused by factors beyond my control or by people who made me feel powerless. When I took ultimate responsibility for my thoughts and actions, I realized the power of choice.

God gives us all the power to choose. We can choose to be less than what we are designed to be, act less, think less, have less, produce less than we are capable of. We can choose to seek the success we are destined to have.

Think about it. What makes you any different than the successful people you know, read about or hear about? Most of us are given the same abilities to achieve wonderful things, but at times we let our choices limit us.

When I could start making my own choices, I knew there

was no end to the things I could achieve. I knew God gave me tests at times to show me that I had the strength and courage to handle anything. In time I found the resilience to withstand the resistance. I dispelled what others negatively predetermined to be my destiny. I believed that God had other plans for me than to remain a fruitless product of my circumstances.

Some would say to me, "If anyone ever had a reason to be everything opposite than what you are today, it was you."

I never agreed with them because I know that was not the destiny designed for me. In my mind, there was no real reason for me not to succeed.

If you want your current situation to change and you have the power to do so, change it. Don't let current obstacles or past circumstances prevent you from living the life you were meant to live. You have the capacity to achieve the things you desire. You must make the decision to be the person you were designed to be.

Define Success

"Accept no one's definition of your life,
but define yourself."
Harvey Fierstein

First, define what success means to you. I personally like Webster's dictionary meaning for success as a favorable or desired outcome. To me that means whatever idea or thing you are working on will be successful as long as its outcome is pleasing to you.

People often equate money with success, believing if they have a certain amount of money and a certain number of things, they are successful. Success is so much more than just money. Just think of all the financially wealthy people who are unhappy or who have committed suicide. I'm bringing this point to your attention because I don't want you to short-change yourself.

You can strive for success in all that you do and all that you are. Success can be found in so many accomplishments. Success can be in training for a marathon. Success can be in raising healthy, educated children. Success can be in having loving and supportive relationships with your spouse, family and friends. Success can be in receiving your diploma, GED or college degree. Success can be in staying off drugs or alcohol. Success can be in completing your first sermon, novel, play or movie. Success is infinite.

Success is up to you. You set your own limits. What would you like to be successful with? Think about it! Act on it! Strive for success! I think of it as a cheer. Once you strive for success and achieve it, you'll crave it over and over. As a result, you will set more goals and challenges because you've proven to yourself that you can be successful.

What does success mean to you? You may need to get in a quiet place and think about your answer. You may have to start answering the question and then come back to it later. Defining this is definitely not a task you want to rush through. Imagine yourself having the things you want and being the type of person you want to be. Make your personal meaning of success something that you strive for daily.

Your Belief System

"When nothing is sure, everything is possible."
Margaret Drabble

As children we had a hard time separating reality and imagination. I can remember being a small child and believing monsters were lurking in my closet and under my bed at night. Before bed I would make certain my closet door was shut completely, and I'd put a chair in front of it to keep the monster inside. I would also tuck my sheets and covers tightly under my mattress, flick my light switch off and race to my bed, sliding into my self-made cocoon to keep the monster under the bed from getting to me. I won't disclose how old I was before I stopped believing there were monsters in my closet and under my bed. The point I want to make is that I had to dismiss that belief before I could sleep soundly.

What beliefs do you have that keep you from sleeping soundly? How many times in your life have you been told that you couldn't achieve a specific goal? How many times have you been discouraged by others who tell you to stop dreaming and to start thinking and acting "realistically"? Did you stop to ask whose reality they were referring to? Was it theirs or was it yours? When you believe someone else's reality is your own, you are forced to narrow your thinking. You allow someone else's belief system to define you.

I can't count the times I drove myself to the brink of insanity trying to conform to a definition that I had not set. I wanted to please everybody and I needed everyone's approval. Believing that I was unable to make decisions for myself, I moved through life like a puppet, allowing others to pull and guide me in the directions they wanted me to go.

Who are you allowing to pull your strings? Can you relate to being detoured from your path and guided in a direction based on beliefs that were not your own? Sometimes it happens because we condition ourselves to believe that others know what's good for us. Remember the statement, "If you know what's good for you...." It was always followed by instruction from someone who felt he or she knew what was best.

For years I conditioned myself to accept the beliefs of others as my own. I traveled down one dead-end road to another. It is imperative to dismiss belief systems that prohibit the achievement of personal goals and dreams. You have to condition your mind to believe you are capable of making sound decisions that will enhance your life.

Allowing your conscious mind to hold on to the negative beliefs will surely manifest into those beliefs. When you make a decision to dismiss the negative beliefs, you allow your mind to open to a channel for sound guidance. You will allow your creativity to flow to find ways to achieve what at first seemed impossible. You will become more confident in yourself and in your actions. Believe the only limitations you have are those that you set. When you argue for your limitations, sure enough they become yours. When you argue for your dreams, sure enough, they become yours.

Never Settle for Average

*"When you do the common things in life in an uncommon way,
you command the attention of the world."*
George Washington Carver

People used to tell me that it was okay to be classified as the average Joe or the average Jane. They used to say the formula for life was to go to college, study hard, find a husband (or wife), get a good job with good benefits, work hard and put a little something away each week for retirement. Now for some, that formula works.

They graduate from college, marry their college sweethearts, find decent jobs with decent benefits, hope for promotions, have children, and for a while, become content with their lives. To keep up with expenses, like mortgages, taxes, bills and childcare, they go back to college to learn new skills. With their newly learned skills, they change jobs, striving for a pay increase while their expenses increase. They continue to work hard just to get by.

They perpetuate the cycle through their children as they advise them to go to college, get good grades, find a good job with good benefits, etc. To sum it all up, it's like saying live, die and somewhere in the middle, trade hours for dollars.

Getting by is what the average person does. The average person in America watches about 29 hours of television per week.

The average person reads one book per year and it's usually fiction. The average person works 40 hours a week for 40 years to achieve poverty. The average person is two paychecks away from being homeless and just one paycheck away from having his or her car repossessed. How does average sound now?

I'm always inspired by stories of successful people. These are the people who think and operate at levels that are high above average in order to achieve their goals. We tend to relate high achievement to people we see or hear about, like Oprah Winfrey, Bill Gates or Michael Jordan. The thing that I realized about these people is that they are human. Yes, what a revelation, they are human just like you and me.

They did not possess supernatural abilities to achieve their levels of success. The apparent fact is that they were driven not to be average. They kept trying after failing and did not give up like the average person. We all have the drive to be successful, but too often we are complacent with an average mentality and do not go after the things we really want.

I am inspired by people we all see and hear about and by those people who are not in the public eye. I recall giving a speech to some graduating seniors. Many of them had to overcome incredible odds but still managed to graduate on time. One young man had been abandoned by his parents and was living in an apartment that had no heat or lights. He often went days without eating. He had dreams of continuing his education and obtaining a degree that would help him pursue a career in the music industry, but adversity caused his dreams to slowly vanish.

That young man suffered for almost his entire senior year of high school until he confided in one of his teachers. His teacher provided a secure place for him to live. Not only did that young man graduate on time, but he also acquired a four-year schol-

arship to a reputable university. That young man operated high above average and proved that he would not let his circumstances stop him from receiving his education.

That was a tremendous accomplishment. He could have easily given up and turned to a life on the streets—the unfortunate path that proves to be the demise of too many of our youths today. He could have subjected himself to selling drugs or taking drugs. But this young man knew that life had bigger and better plans for him. He chose not to choose an easy path, but to instead take responsibility in working toward his dreams.

Give Me Ten More

"A champion is someone who gets up when he can't."
Jack Dempsey

Within all of us lies a divine energy that makes the impossible possible. This energy drives us to get up after being knocked down several times. It's this energy inside that urges you to do a certain thing, complete a task or start a project. We all were born with it. The unfortunate thing is that most people don't realize this energy exists within them. Are you one of these people?

After you've been discouraged from pursuing your ideas or even knocked down while in pursuit, do you give up instead of tapping into that energy? In the depths of your being, do you know you should follow through but you just can't seem to get with it? Don't fret, because like most, you're not the exception, but the rule. From time to time we all get discouraged, disgusted and disappointed. But it's the mark of a truly successful person who chooses to continue to fight the good fight by using that divine energy.

Speaking of the good fight, what fight do you hear most Americans struggle with? Millions of Americans fight the battle of the bulge. They contemplate questions like: Low carb or low fat? Weights or cardio? South Beach Diet or Atkins? The list goes on. There are many who never win the battle because they

give up too quickly in discouragement, disgust and disappointment. They choose not to tap into that divine energy that can make the impossible possible.

I can recall some years ago, when I fought with being overweight. I knew that the 220 pounds I carried on my five-foot-eight inch frame was not a healthy choice. My family had a history of health issues, like hypertension, diabetes, heart disease arthritis and cancer. I had to make the decision to change my unhealthy habits or pay for them later. Realizing that I needed some help with this battle I sought assistance from a group called Integrated Fitness run by one of the toughest nutritionists and trainers I had ever met, Dave Davis.

Dave became my personal trainer and in the beginning I could not stand him. He urged me to change habits that I had grown very comfortable with like eating late at night, keeping loads of junk food in the house and skipping meals. Dave would always tell me, "Either you can work out hard or you can work out smart. If you keep eating the same way you always have, your body will never change."

Not only did I want my body to change but I also wanted the way I felt about myself to change. The change did not happen over night like I wanted it to. I did not always choose apples over Snickers bars, but with each month I saw progression. I was able to build up the repetitions I did with each exercise routine Dave planned for me. At times, the exercises were grueling. I just returned for more pain each training session. I would be sweaty and gasping for air but Dave would take no pity on me. When I felt like I could not move another inch and my muscles ached from exertion, he pushed harder.

I managed to muster up enough air in my lungs to say, "I hate you, Dave. I hate you."

He would reply, "I know you do. Now, give me ten more."

In my mind I was thinking that he was surely insane if he thought I was going to do anything but get my gym bag and leave. As I looked into his eyes and could tell he was serious, I knew I was trapped between him and my conscious. Facing Dave seemed much easier than dealing with the guilt of not completing my task and increasing my progress. After stalling the few seconds he allowed, I gathered strength from tapping into my divine energy and performed the repetitions he demanded.

The weeks went by as I watched my body transform before my eyes. I was glad I had done what I was told. With my new knowledge of nutrition and exercise, I was able to change my unhealthy habits to lead a more health conscious lifestyle. Sometimes the hardest thing to do when striving for success is breaking those negative habits.

The misconception people have is that it's easier to keep the routine of those negative habits. They don't realize they are keeping themselves in regression rather than working toward progression. I often think back on the encouragement from Dave when I'm trying to complete tasks or projects. When I want to quit, I just say to myself, "Give me ten more."

The next time you are discouraged, disgusted, disappointed and ready to give up, tap into that divine energy that makes the impossible possible. Tell yourself, "Give me ten more." It could be ten more reps, ten more minutes, ten more days, weeks or months but when you tap into that energy to complete your task, you'll get closer to the success you are destined to have.

Evaluate Your Network

"Be courteous to all, but intimate with few, and let those few be well tried before you give them your confidence."
George Washington

How many times have you kept certain people in your network you knew you should have ridded yourself of? They never have anything positive to say or try to tear down your self-esteem. These are the people who only come around to dump all their depressing stories on your door step and complain about how life is treating them, while they try to get everything they can from you.

As I write this, I am reminded of a story about a woman who was in the hospital for a few days after having a surgical procedure. Another woman shared her hospital room and they learned quite a bit about one another during their stay. One of the women said to the other, "I would like to be your friend after we've gone from here.

The other woman replied, "That's okay, I have enough friends."

This may seem like a mean response but the woman was trying to protect herself from being used. All of the woman's friends were constantly using her, getting her to do things for them. The woman obliged her friends' requests because she wanted to please them.

Unfortunately, that was the woman's idea of friendship. Believing that her hospital roommate would become like her current friends, the woman denied the offer. She truly did not know if her roommate's intentions were to use her, but the experiences she had with her friends made her unwilling to take that risk.

Often we don't change the network of people we are around because of history. In childhood, you had an inseparable friend and you thought that things would always be the same. But as you grew older, views and opinions changed. You grew in different directions, and as much as you'd like to hold onto those feelings from the past, it just didn't seem logical to keep that person that close in your life.

There is nothing wrong with associating from a distance. That way you are not eliminating the person wholly from your life, but you realize you cannot keep your friend close if there is the potential for him or her to anchor you down.

Anchors can be friends and family members. People used to say to me, "Your family can sometimes pull you down quicker than anybody else can." Do you know who the anchors or potential anchors are in your life? Make a list. You must always be cognizant of the distance between you and the anchors. Now that you've identified the anchors, you may be asking yourself, "Who should I be associating with?"

While on your success-building journey, it is important to surround yourself with people of like mind. These are people who share similar goals and characteristics. I like to call these the "W.O.W." people. "W.O.W." stands for working on wealth. Not only do "W.O.W." people want wealth in the monetary sense, but they also strive for wealth in relationships, health, family, spiritual knowledge and charity. These are just a few areas. The list

can be limitless.

Put people in your network who you can grow and learn from; people who will be supportive of your efforts and can offer legitimate advice. At times you'll find it both necessary and rewarding to step out of your environment to add to your network. You may find resources in other parts of the country or other parts of the world. You would be doing an injustice to yourself if you limited yourself to just the folks in your neighborhood or city.

Expand your network by traveling to places where people are doing the things you want to do. Join clubs of interests. Search the Internet to find information on events and conventions being held that can help you on your success journey. Contact your city's chamber of commerce for information of events coming to your city.

Your network and networking skills are crucial. Remember that you too must provide benefits to keep your network strong. Evaluate your network constantly. Are you keeping people in your network who hinder or help? Don't be afraid to change your phone book or update your speed dial to keep that network tight. Keep anchors at a distance. Keep "W.O.W." people like yourself in close proximity by keeping in contact through communications like telephone calls, e-mail, greeting cards and letters.

Dream it, Define it, Do it

"I can do all things through He that strengthens me"
Philippians 4:13

I created a process to help me on my journey to success. It is called the 3D Process: Dream It, Define It, Do It. As children we have vividly colorful dreams. We are encouraged to dream big. With that encouragement, we allow our imaginations to run wild.

I want you to think back to your early childhood days. Think about what you wanted to be. Was it an actor or a singer? Maybe you wanted to be an astronaut. Did you want to be president of a company or a nation? Was your dream to be a superstar athlete? Whatever it was, the sky was the limit and nothing seemed too big or too great to achieve.

I can recall playing the "That's my…" game when I was a child. When my cousins and I rode along in the car and saw a fabulous house or a sharp-looking car, we would yell, "That's my house!" or "That's my car!" It was a competition to see who could claim it the quickest. It usually ended in a loud debate. We would get mad at one another and scream back and forth, "It's mine, it's mine!" as if we really owned those things. We would continue on like little fools until we were hushed.

As children, our imaginations allow us to dream of the goals we desire. For some, the thought process changes as we get older.

People begin to embrace learned limitations. The encouragement to dream is no longer there. People may say, "Don't dream so *big.*"

The "realistic" thinking they encourage can force you to narrow your scope, limiting your desires for success and achievement. This so-called "real" thinking may cause you to dream small or stop dreaming all together, keeping you from conquering adversities and achieving your true greatness. Instead of rising beyond the circumstances, you may start to give in to obstacles and give up on your dreams. Don't let someone's definition of what they think is real confine your dreams.

I dreamt of leaving the comfort of a job as an engineer to become a motivational speaker. When I decided to quit my job to pursue my dream, everybody I knew asked what I'd do for money and why I'd give up on the degree I'd worked so hard for. They were accustomed to the security of a 9-to-5 job, but I knew there was no real security with the possibility of layoffs and downsizing. Speaking fulfilled me; helping a company sell vehicles did not. I did not allow their ideas to define my dreams.

If you have been bound by that "real" thinking and find it difficult to realize what your dreams are, there are some simple things that you can do. Start by asking yourself some empowering questions. Ask, what do I stand for? What do I feel strongly about? What do I desire most? How can I turn my situation around? How can I add value to other people's lives? Take a moment to answer these questions. They can help you understand what you are really aiming for in your life. Your dream is crucial, as it is the starting point to achieving your desires.

You must develop the plan to achieve your dream. I like to call this your dream's definition. The definition is important to giving your dream meaning. This is where some let their dreams fall short of glory. Having a dream is like planting a seed. Without

water and nourishment, the seed won't grow. A dream without a definition will not come to fruition.

The definition needs to have proper planning so that it is a valuable tool to help you achieve your dream. This may be the time to invest in a journal so that you can write down your dream and include your definition of it. Doing these things will make your dream tangible and real.

Research your definition to determine what measures need to be implemented in order to achieve your dream. Talk to people who are doing what it is you want to do, and ask questions. Use your network to identify people. Sign up for a course. Go to the library and read books that can advance your progress. Invest in resource materials from experts who already know—this is one of the surest ways to find out "how to."

When I started working to define my dream to become a motivational speaker, I began researching the Internet to find information on those like Les Brown, Zig Ziglar and Tony Robbins. Realizing the impact they had on others, I knew I had to pattern myself after them if I was going to be just as, or more successful. I read their books, went to their appearances and worked to get closer to their networks.

Your definition must also have a timeline. Have you ever heard the saying, "Timing is everything"? How long will you give yourself to achieve your dream? How much time will you set for each task? Your timeline will help you measure your progress. Try to establish a time frame instead of saying, "Before I die, I want to...."

Your timeline can also help you identify the time robbers. Time robbers are those things you think you "absolutely" have to do, like watching this week's episodes of your favorite television shows instead of working on your goals or adhering to someone's last minute request because you want to please them.

Time robbers will take over your schedule and before you know it, a year will have slipped away. You will be no closer than you were to achieving your goal.

Have you ever asked the question, "Where did all the time go?" Be able to account for your time. Your time is valuable and you should spend it on worthy ideas and with worthy people.

Now that you've realized your dream and put the necessary time and preparation into creating the definition, you are now ready to move toward action. You are ready to Do It. Sometimes those two little words seem very easy to say but so very difficult to do. It is time to move that dream that has so much potential into kinetic efforts. By going through the 3D Process, you create a constant awareness of them and your efforts to reach them will become habitual.

Have you ever read the book, "Think and Grow Rich" by Napolean Hill? He wrote, "What the mind of a man can conceive and believe, it can achieve."

I interpret this to mean that once you have conceived your dream and put an achievable definition together, you can proudly work toward achieving it. Don't be afraid to profess your dream. Verbally state your dream to yourself every day upon waking and every night before going to bed. State your dream when you feel like giving up. Share it with the people who are close to you. They may become your greatest cheerleaders. The more excitement you show, the more likely you are to stay with your rhythm. Ask your cheerleaders to help you by contacting you periodically to check your progress. You will be surprised at how supportive people will be when you influence them to be.

You don't have to sell people on your dream. The ones who are routing for you will be impressed by watching you put forth the necessary efforts to achieve success. It took a while for my

friends and family to really believe in my dream, but when my biggest supporter—my grandmother, showed me she was behind me, it confirmed to me that I could show people I had what it took to make it.

Don't be afraid to talk to people who are not in tune with the things you are doing. You will encounter those who will try to discourage you, ridicule you, or attempt to take you off your path. Believe it or not, you need some of these people too because they help you build resilience. Soon you will find yourself immune to discouragement and negativity. Obstacles will be much easier to overcome.

There are a few thoughts I'd like you to keep in mind while on your journey to success:

Your dream requires faith, focus and discipline.

There will be times when you feel you can't continue and you want to give up. You are not alone. We all have those feelings. You must ask yourself how much you want this thing you're going after. Does the benefit outweigh the cost? If the answer is yes, then you must stay the course. Don't be ashamed to pray for guidance and discipline.

Remember that faith is the substance of all things hoped for and the evidence of things unseen. (Hebrews 11:1)

Do not overload yourself by trying to accomplish several things simultaneously. One road. One purpose. One mission.

If you are anything like me, you may tend to take on too many projects at one time. You want to see them all through to completion, but never spend enough time on any one of them to make sure it gets done. I often have to stop myself and pri-

oritize my tasks so that I can understand what needs to be done in order to see the project through before I move on to the next one.

Every thought is an investment in your future, so invest wisely.

At times we can talk ourselves out of something before we talk ourselves into it. When you think that you can't, you can't. Believing that you will have the outcome you want is key to achieving your goals. Our minds are like computers. Much like a computer, what you program into it is what you get out of it. Our actions are actually reactions to the thoughts that we program into our minds. When you want a positive outcome, you must employ positive thinking over and over again.

Always be honest with yourself.

No one will be as honest with you as you are to yourself. Don't believe that something will magically happen for you. Things happen when you put forth the time and effort. Be able to determine when it is time to re-evaluate your situation and make a conclusion on what's working and what's not working. Do not obstruct your progress with denial, thinking that something will just change. The only way to change is to change it yourself.

Rejoice in your progress.

Be happy about your accomplishments. Every inch forward is a step closer to achieving your goals. Don't waste time being too critical of yourself and your progress. I've listened to people downplay their accomplishments so much that they actually end up feeling bad when they've done something great. Try not to criticize yourself about where you think you should be, espe-

cially if you are putting forth the effort. Rejoice about where you are now and keep moving forward.

Leave behind who you are in order to become who you want to be.

We sometimes become afraid of what people may think of us when we attempt to move forward with our lives. The real question is: How will you feel about yourself if you choose not to move forward? It may be necessary to sacrifice ideas, habits and relationships to move forward. Remember, the true relationships always stand the test of time. The people who are supposed to be in your life will be there supporting you as you grow.

Whether you incorporate any suggestions from this book or use other methods, please know the most important factor to achievement is YOU. It is your responsibility to have what you desire and to be who you are designed to be. You have everything you need to get started on your journey to success. Master your control. Master your success.